VICTORIAN WATERCOLOURS

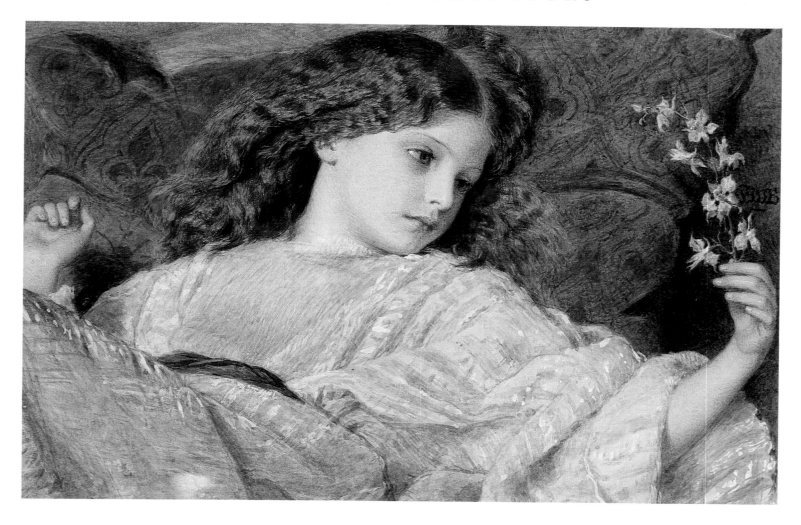

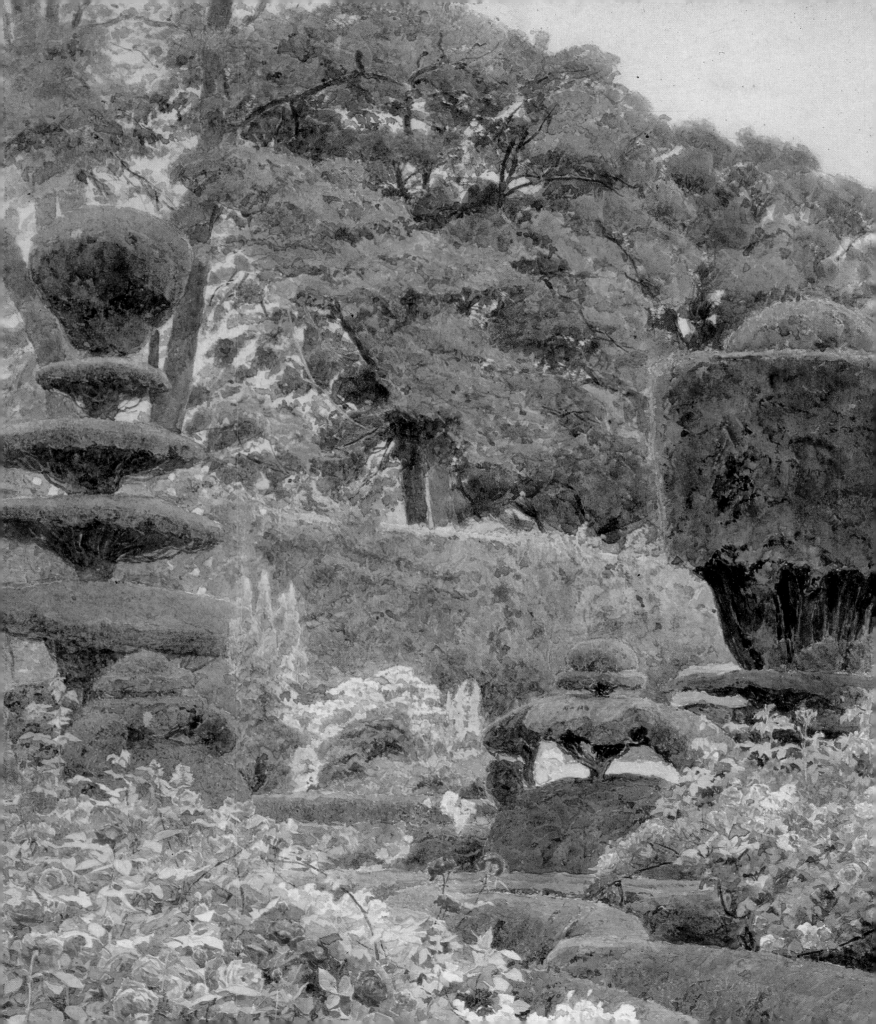

VICTORIAN
WATERCOLOURS

Christopher Newall

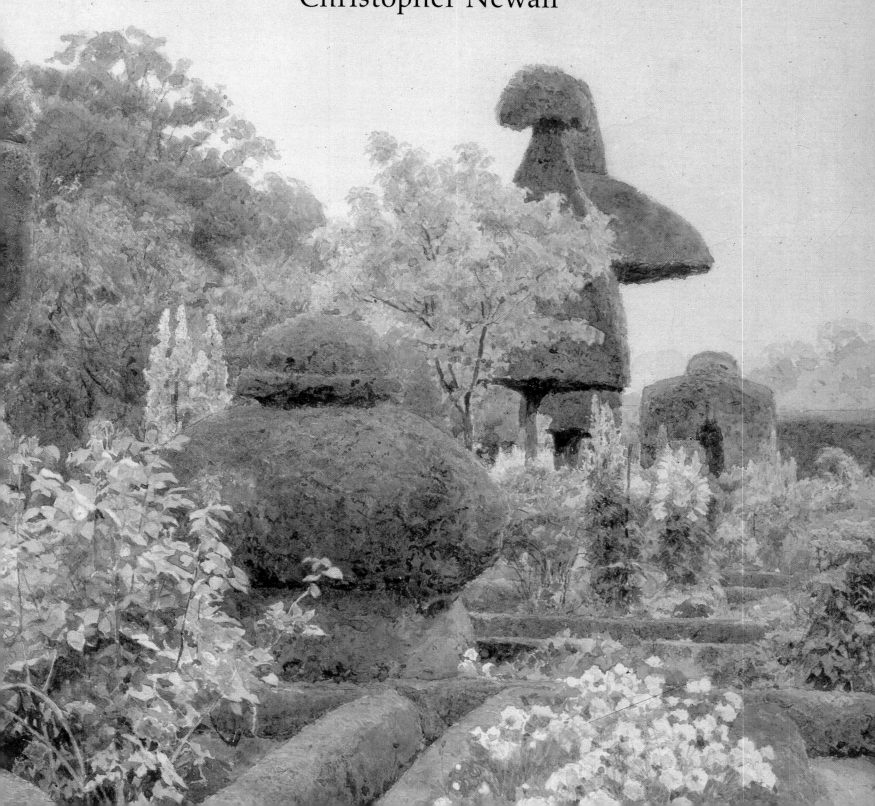

Phaidon Press Limited
Regent's Wharf
All Saints Street
London N1 9PA

A CIP catalogue record of this book is available
from the British Library.

ISBN 0 7148 2811 4

Printed in Singapore

COVER ILLUSTRATION:
Carlton Alfred Smith, RI, RWS (fl. 1871–1916).
Recalling the Past, 1888 (detail of Plate 97).
Watercolour. London, Victoria and Albert Museum.

HALF-TITLE:
Sir Frederik William Burton, RHA, HRWS (1816–1900).
Dreams, c. 1861.
Watercolour and bodycolour, heightened with gum arabic,
20.3 x 30.5 cm. (8⅛ x 12 in.) New Haven, CT, Yale Center
for British Art, Paul Mellon Fund.

FRONTISPIECE:
George Samuel Elgood, RI (1851–1943).
Roses and Pinks, Levens Hall, Westmorland, 1892.
Watercolour, 31.8 x 49.5 cm. (12½ x 19½ in.)
Private collection.

CONTENTS

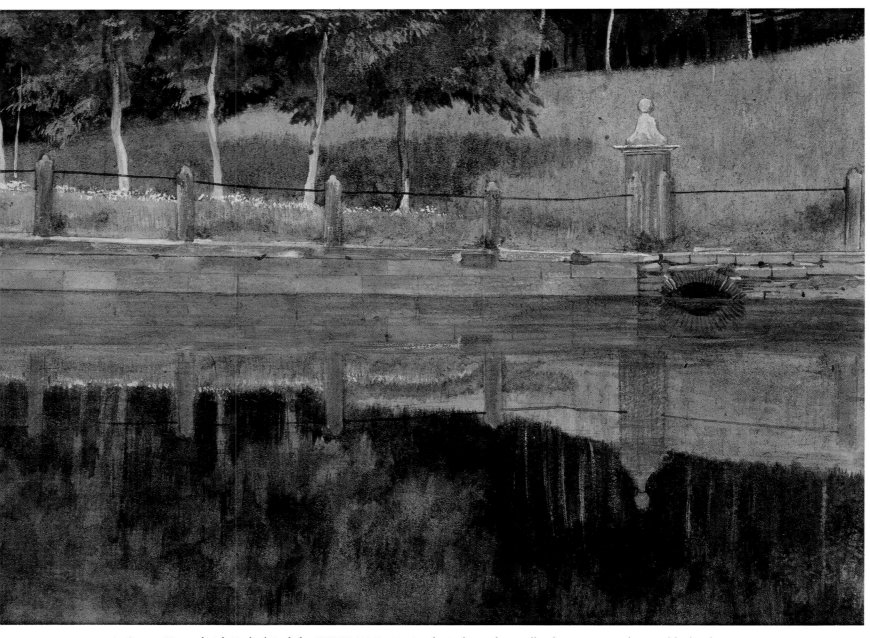

1. George Howard, 9th Earl of Carlisle, HRWS (1843–1911). *The Fish-Pond at Vallombrosa*. Watercolour and bodycolour, 16.8 × 23.5 cm. (6⅝ × 9¼ in.) Collection of Richard Dorment

For Jenny

PREFACE AND ACKNOWLEDGEMENTS

The Victorian period was rich and prolific in the creative spirit of its painters. In the field of watercolour painting there was an unprecedented surge of activity and the age gave rise to some of the most beautiful and extraordinary works ever to be painted in that medium. A vast range of techniques and subject-matter was explored and certain distinct stylistic changes occurred. These factors brought about a minor revolution in the art of watercolour painting before the middle of the nineteenth century and determined the character of that art for some fifty years. As the century drew towards its close the preoccupation with style and technique lessened, and to a great extent watercolourists reverted to more long-standing traditions. Thus the subject to which I have addressed myself has at least a vague beginning and ending.

In a short book I propose to concentrate on the watercolourists whom I find most interesting and who represent the age as I understand it. I have referred to and provided illustrations of watercolours by various little-known painters because I believe that the history of the period depends for its richness on the careers of many minor figures of idiosyncratic and distinct talent. Conversely, I have ignored some important and esteemed artists, either because their work is relatively familiar and therefore does not require a token representation, or because their careers do not correspond to my admittedly subjective view. This book was never intended to be an encyclopedia of watercolour artists; no disapproval is implied by the omission of a particular painter's name.

Many people have contributed to this book. Friends whose intuitions and knowledge have helped me form my own ideas have been Judy Egerton, Julian Hartnoll and Andrew Wilton; they will not necessarily agree with my conclusions but I remain grateful for all that they have shared with me. I am further indebted to Francis Hawcroft, James Holloway, Huon Mallalieu, Hilary Morgan, Sue Ryan, Robert Snell and Rosemary Treble. Penelope Marcus, who suggested that such a book should be written in the first place, has given me great encouragement; I am grateful to her for asking me to write this book, and for all her help. Diana Davies has given invaluable editorial advice.

I have met with a friendly and generous response on the part of the many museum curators in whose company I have looked at watercolours in public collections. I am proud to be allowed to illustrate many beautiful watercolours from museums in this country and in the United States, the majority of which have not been reproduced in colour before. I acknowledge with gratitude the kind help that I have received from the staff of these museums, the names of which appear in the captions attached to the plates.

A further delight has been the privilege of seeing collections of watercolours belonging to private individuals, some of whom were old friends, others people I am fortunate to have met in the course of writing this book. I have been honoured by permission to illustrate watercolours belonging to many private collectors, including those who have preferred to remain anonymous in the captions attached to the plates.

I have had much kind help from auctioneers and picture dealers. Alice Munro-Faure of Sotheby's provided me with the transparencies for the Half-title and Plates 22, 23, 47, 54 and 69; Miranda North Lewis of Christie's those for Plates 21, 63 and 78; Robin Barlow of Bearnes that for Plate 11. Bill Drummond provided me with the transparency for Plate 86; Richard Hagen that for the Jacket; Peter Nahum those for Plates 19 and 74; Bill Thomson of the Albany Gallery that for Plate 51; and Christopher Wood those for Plates 32, 92 and 95.

I have very much enjoyed writing this book, and I have learnt a great deal in the process. I am sincerely grateful to all those who have encouraged me with their enthusiasm and interest.

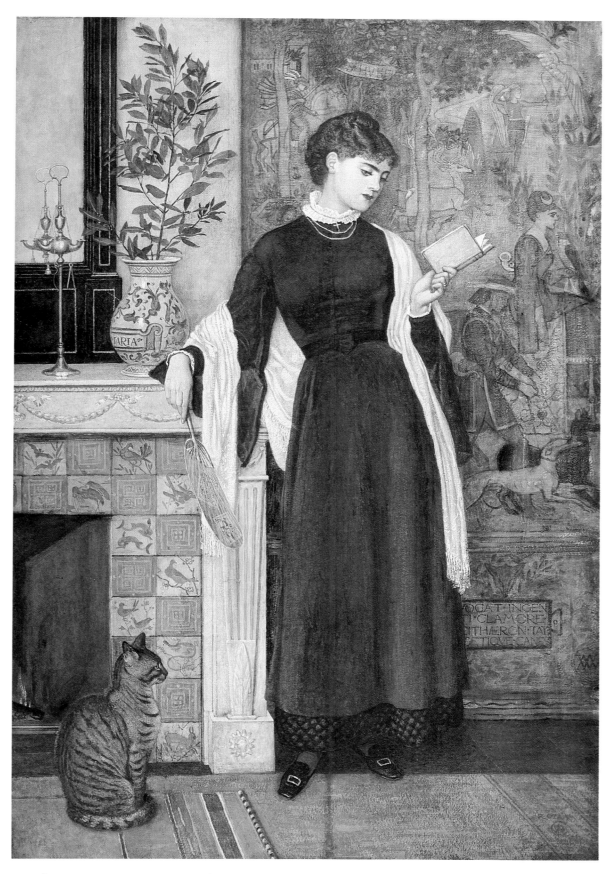

2. Walter Crane, RWS (1845–1915). *At Home: A Portrait*, 1872. Watercolour and tempera, 71.1 × 40.7 cm. (28 × 16 in.) Leeds City Art Gallery

3. Alexander Macdonald (1847–1921). *A Study of Opal in Ferrugineous Jasper from New Guinea*, 1884. Watercolour, 15.2 × 15.6 cm. (6 × 6⅛ in.) Sheffield, The Ruskin Gallery – Collection of the Guild of St George

INTRODUCTION

Watercolour painting has come to be seen as a peculiarly British form of art, and one that received its finest expression during the period which coincided with the careers of J. R. Cozens, Girtin and Turner, approximately from the beginning of the last quarter of the eighteenth century to the middle of the nineteenth. This great tradition was by no means extinguished during the second half of the nineteenth century. Succeeding generations of Victorian artists found that watercolour lent itself to the effects of brilliant colour and rich tone which were amongst the qualities demanded by, and which characterize from an historical standpoint, the taste and art of that age.

Victorian watercolour painting represents both a divergence from the approach and technique of the earlier English watercolourists, and a rapid evolution of their principles. Victorian watercolourists rebelled against the conventions and constraints of a less adventurous age but also saw themselves as heirs to a century-old tradition. Some of them were participants in the major artistic developments of the day; others were isolated from the mainstream.

Watercolour was used to record all aspects of contemporary life and the surroundings amongst which that life was led. The appearance of the landscape, architecture, and the people themselves, was rapidly changing, and this process was documented by a multitude of watercolourists. Their paintings reveal a view of the world which derives on the one hand from a romantic consciousness and an occasionally hallucinatory imagination, and on the other from the humility of dispassionate observation. With their fastidious technique and discreet purpose, they convey much about the moral and neurotic temperament of the age.

The nineteenth century was marked by a fundamental materialism. The Victorians were fascinated by the essential character of physical objects in nature, and indulged a passion for the description and classification of materials. They created and utilized a style of painting which served to record accurately the objects under scrutiny, as in Alexander Macdonald's *Study of Opal* (Plate 3). Most Victorian artists aimed to represent the physical world realistically, and those who collected paintings were delighted to recognize the type and character of objects depicted, and to comprehend the elements of a composition. Whether purely documentary and investigative, or depending upon imaginary, even fantastic, visions of the world, Victorian watercolour painting portrays an apparently familiar scene, and aims to spark a reflex of recognition in the mind of the individual. Thus the obsession with realism and accuracy in detail and colour produced the intense and compelling character of much of what was painted.

For a generation of artists realism was a matter of professional necessity; the *Art Journal* observed in 1857: 'richness, depth, substance, and finish, are in these days indispensable, if reputation is to be achieved or sustained.' Only in the latter part of the century did a new aesthetic creed emerge which made the artist's expression, rather than the spectator's ability to recognize the nature of the subject, paramount.

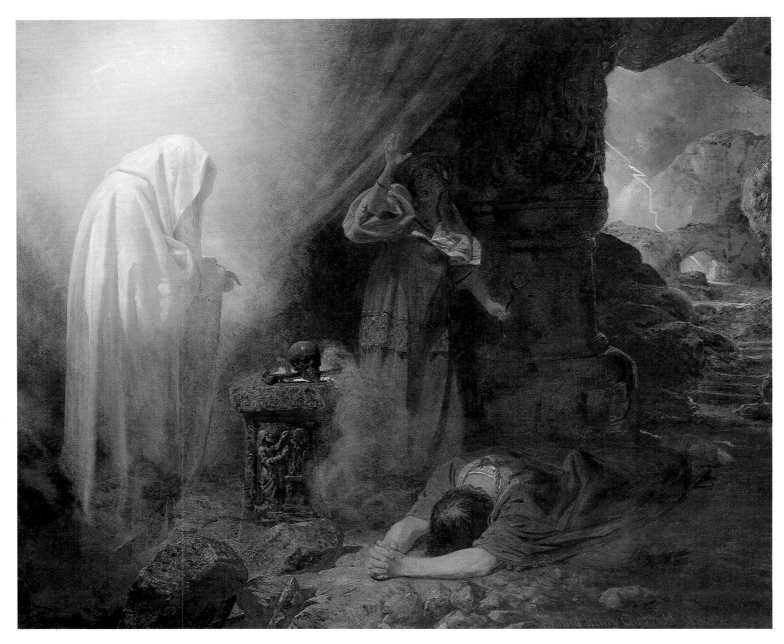

4. Edward Henry Corbould, RI, RWS (1815–1905). *Saul and the Witch of Endor*, 1860. Watercolour and bodycolour, 66 × 78.7 cm. (23 × 61 in.)
Property of Sutton Place Foundation

1 STYLE AND TECHNIQUE

A revolution occurred in the realm of watercolour painting when, in the 1830s and 1840s, artists adopted the use of bodycolour as a technique. The introduction of Chinese White as a manufactured pigment upset the convention, which had been established in the eighteenth century, that watercolours should be built up in thin washes of translucent colour on sheets of white paper, the colour of which was used to illuminate the lighter areas of the composition. The first generation of Victorian watercolourists discovered that, by mixing white paint with pigments to create opaque colours of even texture akin to gouache, they could achieve a richer and more consistent tonal range, and that colour which had a thicker consistency was better adapted to the intricate drawing of detail and the description of the texture of surfaces. More traditional or conservative painters admitted the use of Chinese White to provide brilliant areas or points of reflected or direct light in their compositions.

From the start the use of bodycolour was a matter of controversy and acrimonious discussion. While many continued to regard it with disfavour, for William Henry Hunt and John Frederick Lewis, and subsequently for the Pre-Raphaelites and the generation inspired by the art-philosophy of John Ruskin, a return to what was called the pure watercolour technique was unthinkable. The *Art Journal* repeatedly referred to the different factions in the debate for and against the use of bodycolour; in 1863 for example the following account appeared:

> The conflicting claims of transparent and opaque colour have yet their several adherents. The pure practitioners, however, of that which pretends to be the legitimate method, are each year becoming fewer in number. The increasing desire for detail, the value of force and firmness in the lights, the advantage of contrast between parts which should stand out in solidity and passages that are better just in proportion as they retire into liquid shadow, all put a premium upon an opaque medium when used with skill, moderation, and discretion.

Three years later, however, the *Art Journal* was 'glad to observe a reaction from the immoderate use of opaque colour which some time since threatened to corrupt the purity of the practice of former years.'

Ruskin, in *The Elements of Drawing* (1857), refuted the contemporary charge against bodycolour painting:

> This mixing of white with the pigments, so as to render them opaque, constitutes body-colour drawing as opposed to transparent-colour drawing, and you will, perhaps, have it often said to you that this body-colour is 'illegitimate.' It is just as legitimate as oil-painting, being, so far as handling is concerned, the same process, only without its uncleanliness, its unwholesomeness, or its inconvenience . . .

Ruskin besought his students to: 'Use Chinese white, well ground, to mix with your colours in order to pale them,

instead of a quantity of water. You will thus be able to shape your masses more quietly, and play the colours about with more ease;' having established the 'legitimacy' of the method he eulogized its virtues:

> I say, first, the white precious. I do not mean merely glittering or brilliant: it is easy to scratch white sea-gulls out of black clouds, and dot clumsy foliage with chalky dew; but when white is well managed, it ought to be strangely delicious, – tender as well as bright, – like inlaid mother of pearl, or white roses washed in milk. The eye ought to seek it for rest, brilliant though it may be; and to feel it as a space of strange, heavenly paleness in the midst of the flushing of the colours.

The cult of bodycolour persisted until late in the century. In 1896 Kate Greenaway considered its status in a letter to Ruskin; she wrote: 'I'm so longing to try more body-colour. It's a curious thing everbody runs it down – yet – all the great water-colour people (the modern ones) have used it – W. Hunt, Walker, Pinwell, Rossetti, Burne-Jones, Herkomer.' The history of Victorian watercolour painting is bound up with the use of bodycolour: realism of representation, as well as the strength of colour and tone and the richness of texture, depended on the use of pigment made opaque by the addition of Chinese White.

During the Victorian period there emerged two distinct types of watercolour: the finished work made by professional artists for the purpose of exhibition; and the sketch or preparatory study. Finished watercolours, on which artists worked for months at a time, such as Edward Henry Corbould's *Saul and the Witch of Endor* (Plate 4), which was shown at the New Water-Colour Society in 1860, were large in scale and allowed watercolourists to feel confident that they could compete on equal terms with painters in oil. These exhibited watercolours were the works by which an artist hoped to establish his reputation and on which his professional expectations depended.

As finished watercolours became more elaborate in style and distinct in purpose from the preparatory sketches and drawings on which they were based, a mood of nostalgia for a simpler style of watercolour painting set in. In November 1862, the Old Water-Colour Society held its first Winter Exhibition of 'Sketches and Studies by Members'. J.J. Jenkins, later President of the Society, wrote: 'It was urged that exhibitions of sketches would prove to the Public highly interesting and instructive, as they would display the artistic motive from the slightest rudimentary commencement to the more elaborated sketch drawn direct from nature.'

From the beginning the complaint was made that artists tended to introduce finished works to the Winter Exhibitions, and thus upstaged the true purpose for which they were organized. The *Art Journal* observed in 1867: 'Artists now spend days and weeks over a study, when formerly they would have knocked off a sketch in a couple of hours.' Jenkins warned: 'It is at all times difficult and perhaps dangerous to limit an artist's freedom of expression. What one may call a sketch another considers finished. Still little by little the impression gains that the Winter Exhibitions gradually trend towards those of the summer months.' J.L. Roget concluded in 1891 that 'there has in later times been little, if any, difference in completeness or "finish" between [members'] summer and winter exhibits, except that the latter have a white margin and the former are closely framed in gold.' The importance of exhibiting finished watercolours at any opportunity lessened only when watercolourists no longer depended for professional renown upon the impact of a few spectacular works in the crowded exhibition forum of the two watercolour societies.

Considerations of finish could be ignored, at least until the 1870s, only by artists who used watercolour for personal and experimental purposes. Many painters, including those who regarded oil as a more appropriate medium for the public display of painterly skill, resorted to watercolour to work out ideas for compositions, or to study the colour and surfaces of their subjects. Sir Edwin Landseer, for example, used watercolour and bodycolour over a chalk outline in his *Study of a Horse* (Plate 5); because the drawing was never intended to be displayed only certain areas, and details with which the artist was particularly concerned, have been worked up to a realistic level.

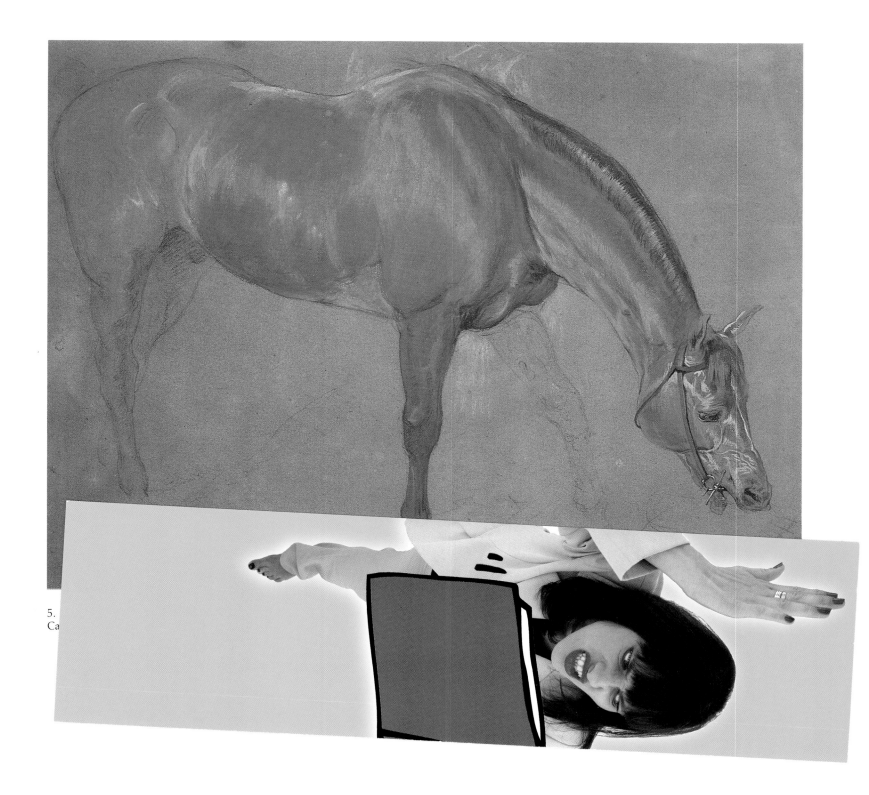

Charles West Cope, like Landseer a member of the Royal Academy, resorted to watercolour in *Girl holding a Slate* (Plate 6), which is thought to be a portrait of his daughter.

In landscape painting the difference between watercolours painted for the private edification of the artist and those painted for the gratification of public taste can be demonstrated by comparing Ruskin's *The Walls of Lucerne* (Plate 7) with a view of the same city by Ruskin's friend Alfred William Hunt (Plate 8). The first represents a form of pictorial notation whereby meditations on the landscape and buildings under scrutiny may be rapidly recorded; the second is a minutely detailed construction which allows the spectator to explore the architecture and environs of the town, and which is complete in itself. Both are beautiful and stem from each artist's affection for the place, but they represent different artistic objectives.

A wide range of new artists' materials and colours was introduced in the nineteenth century; in some instances these were the by-products of contemporary scientific and industrial discoveries. Chinese White was available from 1834; Viridian Green, Cadmium Yellow, Ultramarine, Magenta, Cobalt Violet and Yellow, and Manganese Violet were introduced during Victoria's reign. Ruskin recommended: 'Cobalt, Black, Lemon yellow, Raw sienna, Mars orange, Brown madder, Smalt, Gamboge, Cadmium yellow, Burnt sienna, Extract of vermilion, Burnt umber, Antwerp blue, Emerald green, Yellow ochre, Light red, Carmine, Vandyke brown, Prussian blue, Hooker's green, Roman ochre, Indian red, Violet carmine [and] Sepia' to the readers of *The Elements of Drawing*; two of these – Antwerp and Prussian blue – he considered fugitive, but he consoled his pupils with the words: '. . . you need not care much about permanence in your work as yet, and they are both beautiful.'

In the 1860s, when Ruskin was absorbed by the symbolism of colours and the moods that different colours inspire, he urged Edward Burne-Jones towards the use of a lighter range:

> put the black out of [your] box, and the browns, and the indigo blue – or perhaps it might be shorter to shake everything out of the box and then put back in it the vermilion and the violet carmine, and the cobalt and smalt, and chinese white, and perhaps a little emerald green or so, and try what you can do with those, on gold ground . . .

These were to be the rich and sonorous colours of the second phase of Pre-Raphaelitism.

A series of new colours introduced by Mr Miller of Long Acre in 1853 was recommended to students by the *Art Journal* on grounds of cheapness. In 1861 the journal announced that 'Messrs. Rowney . . . are now selling a colour-box, containing ten cakes of colour, excellent in tint and pleasant to work, for the sum of one shilling – just the price which we were accustomed to pay, many years ago, for a single cake.' The commercial distribution of new and vivid colours, which resulted in their widespread availability and relative cheapness, whether sold in cakes, tubes or, as in the case of Chinese White, in bottles, was an important factor in allowing the Victorian watercolourist to indulge his fondness for richness of texture and brilliance of colour.

During the course of the century drawing paper also gradually improved in quality and became less expensive. However, bodycolour was often needed to disguise flaws in the surface of paper, and on other occasions artists complained that drawings were ruined because of its poor quality. J.W. North campaigned for the introduction of paper of more consistent surfaces, and set up his own company to make what he called 'O.W. Paper'; his example led to a general improvement in the standard of manufactured papers in the later years of the century.

The products of a mechanically ingenious society thus transformed the artist's working methods. In 1864 the *Art Journal* was rhapsodic on the subject:

> Furthermore, when the art of water-colour painting consisted of little more than a wash – the resources of the

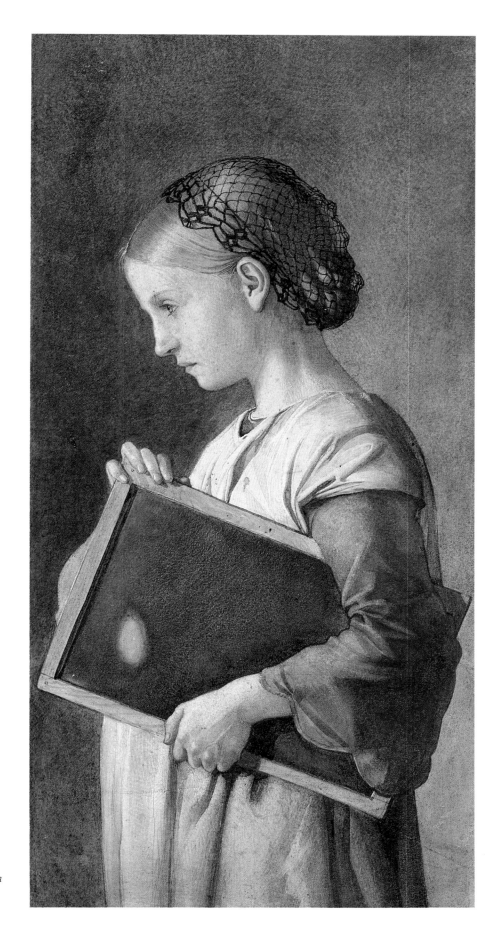

6. Charles West Cope, RA (1811–1890). *Girl holding a Slate*. Watercolour, 49.5 × 24.2 cm. (19½ × 9½ in.) Private collection

artist were necessarily circumscribed within comparatively narrow limits. But as the colours at command multiplied, as the papers manufactured became of every variety of substance and surface, from the smoothness of an ivory tablet to the roughness of a brick and plaster wall, and as the modes of manipulation magnified the power of the skilful master ambitious to push his art to the utmost pitch of elaboration, so did watercolour painting at length extend its dimensions and enhance its glory, so that the question now arises, whether the world, in the entire circuit of its history, in its boasted methods of fresco, tempera, encaustic, or oil, has ever known a medium so consummate in advantage as water.

The variety of new materials available to watercolourists was paralleled by an elaboration in the means used to apply colour and gain pictorial effects. The innovation of opaque bodycolour led painters to devise a new technique, known as stippling, whereby minute touches of colour were placed together in dense patterns to create the forms of a composition. Texture and modulation of surfaces were achieved by variations of the intensity of this pattern and where bright colours were sought combinations of tints were placed together to give shimmering or iridescent effects.

Ruskin believed that exact naturalism depended on the texture of colours, and that by means of stippling the painter could achieve the constant variety of surface found in nature where 'no colour exists . . . without gradation'. Brightness and vivacity and the sense of looming colour or light depended on the broken surfaces of the watercolour. He expressed the potential of such handling in the following homily:

> Give me some mud off a city crossing, some ochre out of a gravel pit, a little whitening, and some coal-dust, and I will paint you a luminous picture, if you give me time to gradate my mud, and subdue my dust: but though you had the red of the ruby, the blue of the gentian, snow for the light, and amber for the gold, you cannot paint a luminous picture, if you keep the masses of those colours unbroken in purity, and unvarying in depth. (*The Elements of Drawing*, 1857)

As the bright local colours of Pre-Raphaelitism gave way to effects of tonality and atmosphere artists resorted to extreme measures to unify and articulate their compositions. Violet Hunt described how her father A.W. Hunt subjected 'delicately stained pieces of Whatman's Imperial . . . to the most murderous "processes," . . . He sponged [them] into submission; he scraped [them] into rawness and a fresh state of receptivity.' Sponges were used to soften or blur the outlines of precisely drawn forms and to simulate the effects of haze or mist. The end of a reversed brush was occasionally deployed to enliven areas of wet colour and knives were used to striate the textures or scratch through to the original whiteness of the paper below. Sometimes watercolourists adopted the techniques of oil painting. Opaque colours were scumbled over transparent washes, and glazes of varnish and gum arabic were applied to give both depth and lustrous texture to the surface.

The virtuosity of techniques used by watercolourists advanced with the century. Hubert von Herkomer gave an account of John William North's method whereby

> the first significant touches are laid in with a stiff-haired brush, using warm colour *very* thickly, as thickly as it comes out of the water-colour tubes, but only dragged or rubbed on in a semi-dry condition. . . . If not dry enough it causes a patchiness; if too dry the colour does not come out of the brush. Blotting paper is indispensable for regulating the consistency of the colour at this stage. ('J.W. North, A.R.A., R.W.S., Painter and Poet', in the *Magazine of Art*, 1893)

In *The Old Pear Tree* (see Plate 90) North painted minute hatchings or scratched tiny strokes over the surface to modulate the colours and to invest them with rich and varied textures. North's friend Herbert Alexander described

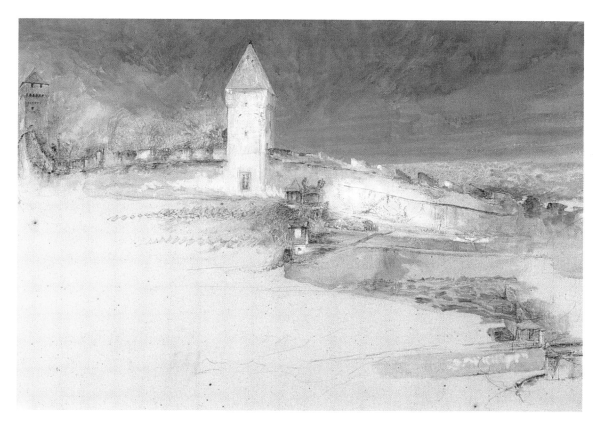

7. John Ruskin, HRWS (1819–1900). *The Walls of Lucerne*. Watercolour, 34.1 × 38.1 cm. (13⅜ × 15 in.) Coniston, Cumbria, Brantwood Trust

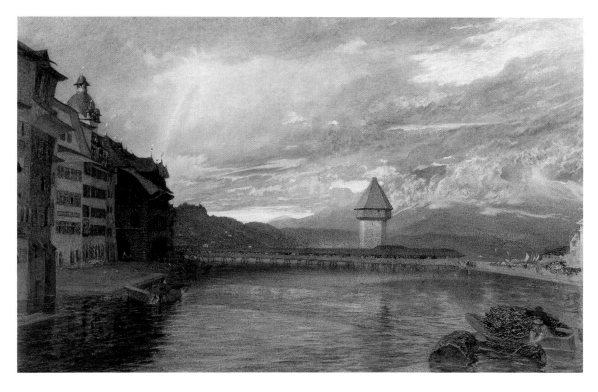

8. Alfred William Hunt, RWS (1830–1896). *Lucerne*. Watercolour and bodycolour, 31 × 48.5 cm. (12¼ × 19⅛ in.) Private collection

how 'an effect of intricate detail is found on examination to be quite illusive – multitudinous form is conjured by finding and losing it in endless hide-and-seek till the eye accepts infinity.'

Herkomer gave an account of his own working method when he painted his watercolour portrait of Ruskin in 1879 (Plate 9):

> I used in those days to paint abnormally large water-colours and always covered the paper first with a wash of some ochre or grey, then sketched the subject with charcoal. I would then commence with a hog-hair brush, working up the ground colour with some fresh tones, and out of a kind of chaos produce a head. Ruskin queried even the possibility of this and would hardly believe that my final outlines and delicate bits of drawing were put in last. His theory was to draw the outline with the precision of an expert penman and then fill in with colour. (J. Saxon Mills: *Life and Letters of Sir Hubert Herkomer*, 1923)

Ruskin's surprise at the way in which Herkomer brought the drawing to a resolution reveals the polarity between the different traditions of sketching line and adding colour, a method which derived from the eighteenth century and which became associated with amateur watercolour painting, and the more modern approach of building up the masses of a composition and adding drawn detail to make the subject recognizable at the last stage.

Although the Victorians avidly seized upon watercolour as a means of record and artistic expression, doubts were expressed about the practical qualities of the medium. Virulent correspondences took place in the *Art Journal* and *The Times* about the impermanence and vulnerability to light of the new and established pigments. In 1886 J.C. Robinson pointed out that the collection of watercolours at the South Kensington Museum, by being 'continuously exhibited in the full daylight for twenty or thirty years past', were 'irrevocably injured'.

Various means were suggested for the protection of watercolours against fading: certain watercolourists favoured sealing their works with varnish; others, including Ruskin, believed the fading process to be inevitable. Fortunately, Victorian houses, unlike the South Kensington Museum, were seldom brightly lit; in fact curtains and blinds were often left closed even during daylight hours. In other collections drawings were kept in folios or flat boxes. Thus many Victorian watercolours have survived in pristine condition.

During the last quarter of the nineteenth century a new preoccupation with the momentary effects of light and movement percolated through the spheres of British art. Even before any native counterpart to French Impressionism of the 1870s and 1880s came about watercolourists were impelled to record the transitory and enveloping effects of weather on the landscape, the blur of movement, and the fleeting facial expressions which might offer insight into the psychology of an individual. These new artistic objectives encroached upon and undermined the occasionally ponderous High Victorian standard of 'finish', and the contemporary view of what constituted realism.

The age of the exhibition watercolour gave way to one in which the virtue of the medium was again understood to be its freshness and capacity to capture the impressions of an instant. Fluency and calligraphic dexterity were the qualities which artists sought to introduce into their drawings, and to achieve these ends watercolourists reverted to simpler and more direct technical means. Bodycolour painting was dismissed by many as inappropriate and tending to lead to a confusion between the different properties of oil and watercolour. North, for example, shifted in his later career towards a pure watercolour technique, finding the use of white, according to Herkomer, 'a continual deadener of the glowing tones he endeavours to produce'.

By the end of the Victorian period artists no longer sought to raise watercolour painting to the level where it might compete in terms of finish and scale with oil, but rather resorted to it for the qualities which made it quite dissimilar: flexibility and adaptability; speed and spontaneity; spirit and expressiveness.

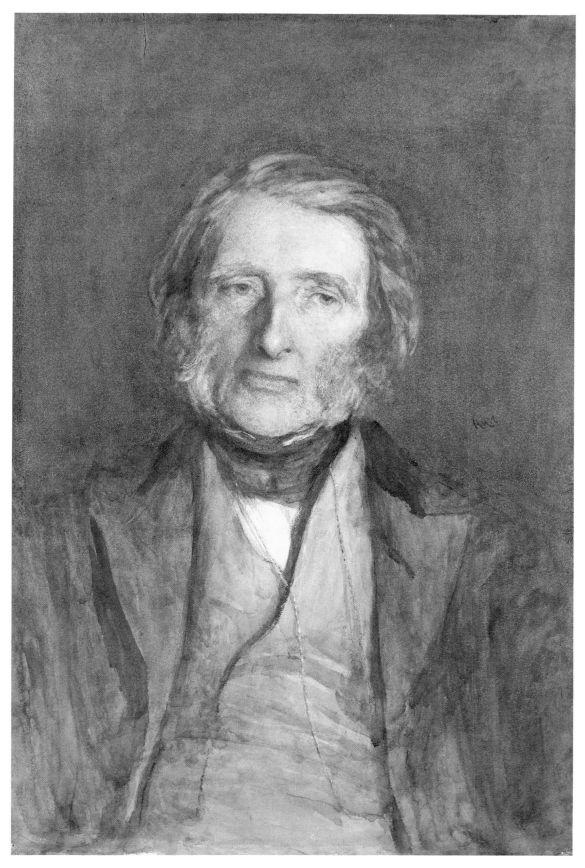

9. Sir Hubert von Herkomer, RA, RWS (1849–1914). *Portrait of John Ruskin*, 1879. Watercolour, 73.7 × 48.3 cm. (29 × 19 in.) London, National Portrait Gallery

Fig. 1. The Royal Water-Colour Society, Pall Mall, London

Fig. 2. The Royal Institute of Painters in Water Colours. Piccadilly, London

During the nineteenth century the art of watercolour painting was practised by artists who took their professional status and careers very seriously. Two societies were supported by watercolourists, and served the twin objectives of exhibiting and selling works by members and promoting the medium in competition with the advocates of oil painting. Considerable prestige was associated with membership of these societies and their histories indicate the importance and popularity of the medium.

The senior association, the so-called Old Water-Colour Society, had been founded in 1804 by a group of watercolourists frustrated by the indifference or hostility shown to the medium by the members of the Royal Academy, a stance which was maintained fairly consistently until the 1870s. Charles Holme wrote of the Academy's unwelcoming attitude: 'The Academy had never treated the art of water-colour painting as one which ought to be taken seriously; it had, indeed, rather gone out of its way to fix upon workers in the medium the stamp of inferiority, and to ticket them as unworthy to be counted among the leaders of the profession.'

The Society fulfilled an important role and attracted a large following. John Ruskin recalled in later life:

I cannot but recollect with feelings of considerable refreshment, in these days of the deep, the lofty, and the mysterious, what a simple company of connoisseurs we were, who crowded into happy meeting, on the first Mondays in Mays of long ago, in the bright large room of the Old Water-Colour Society; and discussed, with holiday gaiety, the unimposing merits of the favourites, from whose pencils we knew precisely what to expect, and by whom we were never either disappointed or surprised.

But by the 1830s the Society had itself become a conservative and exclusive body. In 1831 it was attacked in a newspaper article which opened with the words: 'The monopoly of this institution, by the paltry, mercenary workings of its members, has contributed mainly to its corruption and degradation.' The article anticipated the founding of a new watercolour gallery, 'set afoot . . . on a more enlightened and encouraging principle'. In 1832 the New Society of Painters in Water Colours was established.

From this time on, and throughout the remaining years of the century, a bitter rivalry operated between the two societies. The Old Water-Colour Society had its premises in Pall Mall East (Fig. 1), close to the Royal Academy and National Gallery in Trafalgar Square. The New Society, which changed its name to the Institute of Painters in Water Colours in 1863, also operated from Pall Mall until 1883 when it moved to a palatial new building in Piccadilly opposite Burlington House, the home of the Royal Academy since 1868 (Fig. 2).

Antagonism was fuelled by the fact that watercolourists frequently defected from the junior to the senior society in the hope of better prospects. The Institute became, in the words of Charles Holme, 'to some extent a stepping stone to the ''Old Society,'' because a number of the water-colour painters whose merits it was the first to

recognise were unable to resist the temptation to pass on into the other association, which seemed to them to offer superior advantages of seniority and professional position.'

The question of amalgamating the two societies and combining their interests and responsibilities was sometimes discussed, usually by outsiders at moments when relations between the two were most strained. In the late 1850s each petitioned the government for space to build galleries and offices at Burlington Gardens, where they would have become part of the envisaged complex of society and institutional headquarters which was to be based on Burlington House. However, neither was accommodated; the *Art Journal* concluded that they might have succeeded if only they had acted in unison. A Royal Commission in 1863, which investigated the roles of the Academy and the watercolour societies, favoured the amalgamation of the two societies. Frederick Tayler, President of the Old Water-Colour Society, resisted the move on the grounds that 'the one would not be willing to admit its great inferiority to the other, and on equal terms a fusion could not fairly take place'. In 1878 the *Art Journal* recommended that the two societies should be combined to establish 'one great academy of British Water-colour Art'. In 1881 the Institute 'aspired to nothing less than the consolidation of all water colourists worth taking into account at all into an united body . . .', but succeeded in incorporating the previously independent Dudley Gallery rather than the Old Water-Colour Society. In 1882 the *Art Journal* concluded that 'there has probably never been a time when the tension between the "Old Society" and "The Institute" has been so tightly drawn', and so the unhappy relationship between the two went on.

During the 1870s, however, the Royal Academy became increasingly friendly to watercolourists and the vetting committees for the Summer Exhibitions more disposed to see the merit of watercolours. In 1869 Fred Walker had consoled his friend J.W. North, who had been passed over in the elections to the Old Water-Colour Society, but whose work was accepted at the Academy, with the words: 'So that's all right, stick to it! I think I would as soon be appreciated by the Academy in its present healthy tone, as by the W. Colour Society.' From the mid-1880s the Academy devoted a gallery in the Summer Exhibition to watercolour painting, where small and delicate works might be seen away from the distraction of larger-scale oil paintings.

As the exhibition space in the galleries of the two societies was restricted to a fixed number of members and associates, at least until 1883, young watercolourists without established reputations were at a disadvantage. An important event therefore was the first 'General Exhibition of Water-Colour Drawings' held in 1865 at the Dudley Gallery in the Egyptian Hall, Piccadilly. This was organized by a committee of artists and connoisseurs who, according to the preface of the catalogue of their first exhibition,

> had for their object the establishment of a gallery, which, while exclusively devoted to drawings as distinguished from oil paintings, should not in its use by exhibitors involve membership of a society. These two conditions are not at present fulfilled by any London exhibition. The water-colour societies reserve their walls entirely for members, while those galleries which are comparatively open to all exhibitors (such as that of the Royal Academy) afford but a limited and subordinate space to all works in other materials than oil.

The *Art Journal* applauded this 'boon to a great mass of water-colour artists'; and aspiring watercolourists, many of whom had previously earned parlous livings as illustrators, sought to exhibit probationary watercolours in the Dudley's annual exhibitions.

The Dudley was a runaway success. The *Art Journal* commented in 1868 that what had been 'when established, simply a necessity', was now 'looked upon as one of the most interesting exhibitions of the year'. In the years between its founding and the opening of the Grosvenor Gallery in 1877 the Dudley came to be regarded as a refuge for both conservative and aesthetically advanced watercolourists, and for amateurs as well as

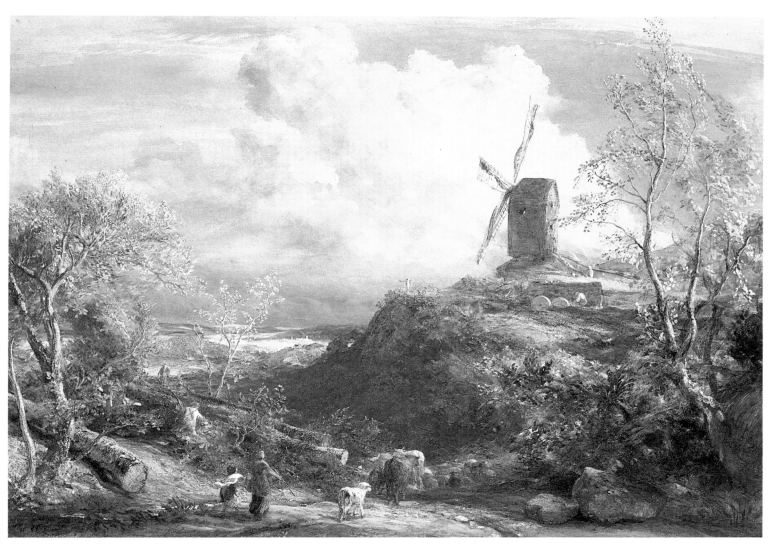

10. Samuel Palmer, OWS (1805–1881). *Landscape with Windmill, Figures and Cattle*, exhibited 1851(?). Watercolour and bodycolour, with scratching out, 53.7 × 75.6 cm. (21⅛ × 29¾ in.) London, Bethnal Green Museum

professionals. The Dudley, because it was established on genuinely liberal principles and was accessible to all watercolourists, supported many artists whose careers might otherwise have failed.

Distinct styles and subjects of watercolour were sometimes associated with the societies. The *Art Journal* wrote in 1861:

> The Old Water-Colour Society was originally a body of landscape painters, and the New began life as a company of figure painters, by way of broad distinction from the senior body; but neither society has been able to sustain the character it assumed, and which was originally given to it.

Samuel Palmer's *Landscape with Windmill, Figures and Cattle* (Plate 10) is representative of the more conservative type of landscape painting which came to dominate the Old Water-Colour Society in the 1850s. Its imaginary and artificial character was prescribed by a tradition of landscape painting which descended from Rembrandt and Jacob Ruysdael and which was assimilated into British art in the eighteenth century. Palmer's watercolour, impressive in scale and technique though it may be, represents a preconceived vision of landscape based on historical tradition rather than a fresh inquiry into the general or local features of the countryside.

The general conservatism of the Old Water-Colour Society did not preclude innovatory and startling watercolours from being shown there. J. F. Lewis and William Henry Hunt were leading members. Edward Burne-Jones was elected in 1864, and the figurative watercolours which he exhibited, although they met with a chilling lack of appreciation, were amongst the most beautiful products of the interim phase of Pre-Raphaelitism. In the 1870s the Society was a meeting-place for the Idyllist group of watercolourists, of which Frederick Walker was the leading member. But by the beginning of the last quarter of the century the Old Water-Colour Society had become an entrenched bastion of old-fashioned ideas about painting.

The New Water-Colour Society, or Institute, was to some extent successful in attracting watercolourists who addressed themselves to historical, biblical or literary subjects. Edward Henry Corbould's *Saul and the Witch of Endor* (Plate 4) may be seen as an example of this type of painting. The *Art Journal* described it as 'ambitious, powerful, and well calculated to show the utmost capabilities of water-colour Art' in its review of the exhibition of 1860. In 1866, however, the *Art Journal* carpingly referred to the Institute as being 'notorious for pseudo high Art'. Landscape was always represented at the Institute, and as the century proceeded a type of rustic scene with sentimentally treated figures came to be associated with its exhibitions. At the end of century the Institute was popular with many painters who were only occasional watercolourists and allowed more dramatic and innovatory uses of the medium than the Society was willing to endorse.

The Dudley Gallery was more heterogeneous in its exhibitions than either of the societies; the lists of contributors include the names of an extraordinary cross-section of artists who were to make brilliant reputations for themselves later in the century. In the 1860s it provided an exhibition forum for various artists who followed and admired Burne-Jones and in whose poignant Pre-Raphaelite-inspired works the dawn of the Aesthetic Movement may be seen. Walter Crane and Robert Bateman and other Dudley artists painted mythological and figure subjects of which the *Art Journal* said in 1869: 'there is . . . dreaminess instead of definiteness, and smudginess in place of sentiment.'

The Grosvenor Gallery somewhat stole the thunder of the Dudley, and certainly became the showplace of Aesthetic painting. From its inception in 1877 the Grosvenor's proprietor Sir Coutts Lindsay invited watercolourists to submit works, and provided a separate chamber where watercolours might be sympathetically hung and appreciated. In the winter of 1880–1 the Gallery's exhibition devoted to watercolours by contemporary artists was seen as competing with the exhibitions of the two societies.

Towards the end of the nineteenth century the argument over the relative importance of oil and

watercolour lost currency. Each medium was accepted in its own right and the feeling of professional rivalry between the protagonists died away. Although the Society and the Institute continued in business, and in fact gained royal patronage in 1881 and 1883 respectively, members were less dependent on them at a time when there were wider opportunities for the exhibition and sale of watercolours.

The late Victorian appetite for works of art gave rise to the Fine Art Society in 1875, and from the start exhibitions of works for sale by contemporary watercolourists were held there. Established dealers like Agnew's bought and sold watercolours by leading artists of the day, and put on annual exhibitions of drawings. The Burlington Fine Arts Club staged memorial exhibitions of distinguished Victorian watercolourists. The principal provincial cities benefited from academies and art societies which exhibited the works of artists who sought local reputations. In Edinburgh the Royal Scottish Society of Painters in Water-Colours was founded in 1878 on the model of the Old Water-Colour Society, and the Royal Scottish Academy exhibited watercolours and included watercolour specialists amongst its associates.

Women artists had their own association in the Society of Lady Artists, but most preferred to exhibit alongside their male colleagues. Many were professionally successful, despite a restriction barring women from full membership of the Old Water-Colour Society, which was enforced until 1890.

Certain artists enjoyed considerable prosperity as watercolour painters. Established figures commanded large fees for their illustrative drawings. John Gilbert, who based his career on this trade, became a very rich President of the Old Water-Colour Society and was knighted. Typical of the type of romantic-historical watercolour that he exhibited is *The Field of the Cloth of Gold* (Plate 11). Other watercolourists supplemented their income by teaching, and some found it hard to survive in their chosen *métier*. J. F. Lewis wrote in 1858 of the despair he felt about earning his living by watercolour painting:

> I work from before 9 in the morning till dusk, from half past six to 11 at night always, I think that speaks for itself, and yet I swear I am £250 a year poorer for the last seven years . . . And for what? To get by water-colour art £500 a year, and this, too, when I know that as an oil painter I could with less labour get my thousand. (M. Lewis: *John Frederick Lewis*, 1978)

Lewis resigned the Presidency of the Old Water-Colour Society in 1858 and turned to the more remunerative production of oil versions of his oriental subjects.

Different artists had their own ideas of how to succeed. Samuel Palmer thought that 'the only quite certain way of making money by water-colours is, I fancy, to do such figures, fruit, and flowers as William Hunt did, and to do them as well.' F. G. Stephens said of Hunt's money-making proclivities: '[He] was unable to resist the crackle of crisp bank notes, a sound which mastered his strongest reluctance to part with a drawing he was loath to sell.' In 1865 the *Art Journal* wrote sarcastically of the commercial instincts of some members of the Old Water-Colour Society:

> Students of nature are content with the production of two or three well considered works, which have a value in proportion to the thought expressed. But men who aspire to the display of seventeen frames, each one of which is made tempting to the popular eye, must, we repeat, be of a higher order in creation than the mere artist. It is obvious that, wise in their generation, they have gone to Birmingham and Manchester and have learnt from manufacturers and political economists how to suit the market, and make the supply equal the demand. We feel that the reproach often cast on the unthrift of the artist meets in these practices absolute refutation.

Watercolourists strove to be regarded as the professional equals of contemporary oil painters, but without

complete success. In financial terms the majority of watercolourists struggled, whereas practically all members of the Royal Academy, however mediocre their paintings, enjoyed reasonable prosperity. The relative unreward of watercolour painting was a constant cause of grievance to its practitioners.

The frontier between professional and amateur artists was a closely drawn one. The status and self-esteem of the former group, which were jealously guarded by the watercolour societies, were not readily achieved by artists who did not need to sell works to earn their livings. Watercolour painting was, however, vastly popular throughout a wide cross-section of society. Countless amateurs occupied their leisure hours by recording the familiar domestic and landscape surroundings, although the reputations of only a few have survived. Watercolour was a medium which aspiring artists could easily experiment with, simply because its practice did not depend on a studio or elaborate equipment.

Instruction in the technical skills of watercolour painting was traditionally received from drawing masters; Ruskin for example took lessons from J.D. Harding; and large groups of students would gather around revered figures like David Cox in the hope of gaining informal tuition or some insight into the master's working method. Dozens of instructional treatises were published during the nineteenth century and the courses they laid out were presumably methodically followed by both professional and amateur painters. Ruskin's *The Elements of Drawing* was written as a reply to the many requests for advice that, in the words of Cook and Wedderburn, he received 'from all sorts and conditions of men and women, from humble students, otherwise unknown to him, and from great ladies or dear friends'. Ruskin offered a lucid explanation of the technical methods of watercolour painting and guided his students to types of subject in which, to borrow his phrase, 'the innocence of the eye' might revel. The programme of this simple and poetic text followed the course that he had established in the landscape school of the Working Men's College, where he had taught in the early 1850s. *The Elements of Drawing* circulated very widely and was highly influential for at least quarter of a century.

Certain private schools gave part-time students the opportunity to meet and sketch or paint together. The most informal and friendly of these was Leigh's in London, which later became Heatherley's School, and there at least watercolour painting was not actively discouraged, as it was at the Royal Academy Schools. If formal art education generally ignored watercolour as a medium young artists themselves occasionally gathered together to organize their own curricula and to set themselves figurative and landscape subjects for sketching sessions.

To pursue any kind of voluntary training, however, required a degree of financial independence, and young painters often faced the immediate necessity of earning their livings. In the middle years of the century many of these found occasional work drawing designs on wood blocks which could then be engraved to provide illustrations for books and magazines.

British social life underwent a gradual but fundamental transformation in this period. The arts were no longer the domain of the aristocracy or court, but were instead adapted to appeal to the expectations, and to express the moods and emotions, of a diverse and multiform community. For the first time in history a wealthy, self-confident and culturally acquisitive middle class assumed responsibility for, and determined the character and direction of, artistic developments.

Watercolour painting in particular depended on the support of the middle classes, whose newly built houses required furnishing with pictures and whose cultural appreciations respected an artist's ability to represent recognizable objects and transmit factual information. Moreover, they believed in an art that was pioneered by artists of their own generation and nationality. Ruskin wrote with telling self-mockery when he described a middle-class household's artistic requirements in *Notes on Samuel Prout and William Hunt* (1879–80):

It is especially to be remembered that drawings of this simple character were made for these same middle

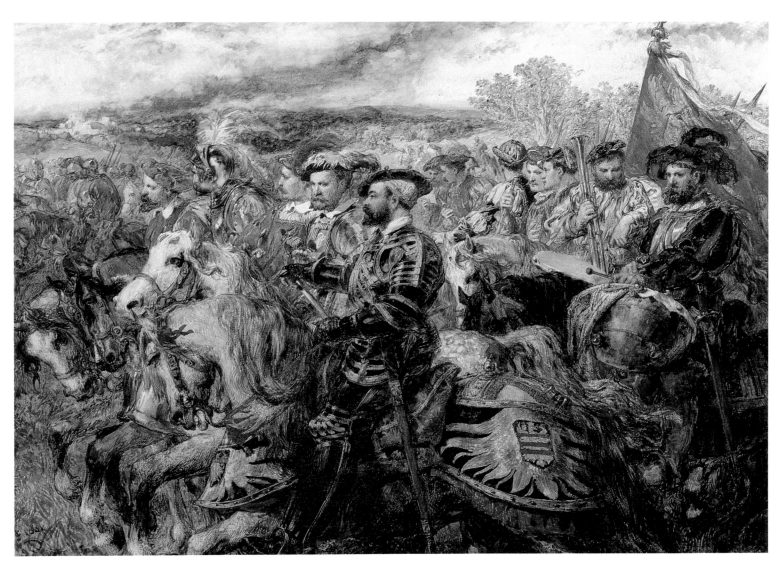

11. Sir John Gilbert, RA, PRWS (1817–1897). *The Field of the Cloth of Gold*, 1862. Watercolour and bodycolour, 48.3 × 66 cm. (19 × 26 in.) Private collection

classes, exclusively; . . . The great people always bought Canaletto, not Prout, and Van Huysum, not Hunt. There was indeed no quality in the bright little water-colours which could look other than pert in ghostly corridors, and petty in halls of state; but they gave an unquestionable tone of liberal-mindedness to a suburban villa, and were the cheerfullest possible decorations for a moderate-sized breakfast-parlour opening on a nicely-mown lawn.

Ruskin and many of his contemporaries believed that watercolour painting was a valuable and important activity, the artistic achievements of which contributed to general happiness, education and spiritual refreshment. The aesthetics and purpose of the medium were endlessly discussed in newspapers and journals, and praise and criticism was freely given. On the whole, the works that were exhibited were seen as demonstrating the zenith of watercolourists' technical and imaginative powers. Even if the Victorian art establishment regarded watercolour as beyond the academic pale, the medium still attracted many good artists and evoked much loyalty in its admirers.

Early Victorian watercolour painting incorporated a hotchpotch of artistic conventions, and at the same time pioneered startling aesthetic advances. Many watercolourists were content to abstract and compose their subjects according to earlier pictorial practices. Others, however, embarked on an objective investigation into the essential qualities of materials, and discovered new technical means whereby they might record the appearance of the physical world.

Two great romantic artists, Turner and Cox, were in the prime of their careers in the 1840s. Both exerted influence upon the careers of watercolourists, who deliberately or unconsciously sought to emulate their styles of painting. However, and perhaps surprisingly, the general pattern of Victorian watercolour painting was not foretold in the work of either.

Turner's art was interpreted in a variety of ways during the later years of his life and after his death. Ruskin acclaimed the brilliant and elaborate watercolours of his great hero's middle years in which a constant variety of surface textures suggests minute detail to the eye – a technical device seen by Ruskin as the link between Turner and Pre-Raphaelitism. But very few Victorians sought to emulate the scale and drama of Turner's compositions. As for the colour studies and abstract arrangements of shape with which he experimented in old age, these remained unknown to artists at large until the late 1850s, and were appreciated only by a generation which independently considered the way in which the eye responds to the harmonies of spatial proportion and conjunction of colour. Thus Turner's influence on succeeding generations was disparate and sporadic; artists as different as Birket Foster and Whistler were indebted to the compositional and technical examples that he set. For many other students of watercolour, 'This greatest of all landscape painters' was, in the words of Alfred William Rich, 'a cause of stumbling and disaster.'

David Cox was relatively more accessible to younger artists than Turner, and many owed their first allegiance to him, although their styles of painting subsequently diverged from his. As the true modernity of Cox's watercolours was only gradually understood his influence proved long lasting: even in the later years of the nineteenth century certain painters considered themselves heirs to a tradition of painting established by Cox.

If the examples of Turner and Cox perplexed their Victorian admirers and seemed to offer an uncertain stylistic direction, other watercolourists of the romantic generation made sensational advances in the 1830s and 1840s, and were applauded as the geniuses of the future.

William Henry Hunt was amongst the pioneers of the use of opaque bodycolour; he perhaps more than any other painter was influential in leading younger artists to adopt its use whenever finish and detail were sought. In addition, Hunt invented new subjects which were in turn adopted by his followers, and in doing so he led the general diversification towards genres other than landscape. He saw no impropriety in subjects of contemporary rustic life. In *The Outhouse* (Plate 12) he painted his wife Sarah standing with a jaunty air at the doorway of a shed.

The wooden beams, barrel and hen-coops, and the boards and wattle from which the building is constructed, are wonderfully drawn in their haywire disorder, but they remain a foil to the model's compelling and provocative gaze. William Makepeace Thackeray wrote: 'If you want to see *real* nature, now, real expression, real startling home poetry, look at every one of Hunt's heads.' Hunt invested his modern-life subjects with a realism which allows the viewer to explore minutely the contents of an interior, and which gives a direct sense of communication with the figures. This psychological intuition was emulated by watercolourists right through the century.

While Hunt was occasionally humorous in his choice of modern-life subjects, many of his followers were overtly sentimental. Frederic Shields, who gained both his technical proficiency and his fondness for rustic subjects from Hunt's example, introduced a quality of winsome charm to his watercolours of children, such as *The Holly Gatherers* (Plate 13). Amongst the most sympathetic portrayers of children was Alfred Downing Fripp, who by approaching closely to his adolescent subjects allows the viewer to participate in their childish antics and excitements. In *Watching the Porpoises* (Plate 14) he described the expressions of carefree delight of a group of boys perched on a weed-strewn rock. As was the case with Hunt's watercolours of children the subject is directly conveyed; the forthright expressions and gesticulations of the boys involve the spectator. Frederick Burton's watercolour *Dreams* (Half-title) is a study of an invalid child, who holds a spray of columbine. The fine stipple of its technique relates it to Hunt's tradition.

W. H. Hunt's most famous invention in terms of subject-matter were the still-lifes of fruit, flowers and birds' nests which he exhibited regularly from 1830. In their microscopic detail and meticulous depiction of the different species of fauna and flora these anticipate Pre-Raphaelite landscape painting of the 1850s and 1860s. In fact, Ruskin, who admired Hunt's still-lifes enormously, and many other contemporaries, regarded them as microcosms of landscape and judged them by the criterion of truth to nature which was applied to landscape painting. A reviewer in the *Art Journal* in 1854 noted that his drawings 'are copied from pieces of judiciously selected way-side turf, cut out by the yard, and kept in living freshness for a month.'

Hunt gained his sobriquet 'Bird's Nest Hunt' from watercolours like *Chaffinch Nest and May Blossom* (Plate 15). In this *tour de force* his various technical resources may be identified. Chinese White was used for the highlights of reflected light, in for example the glossy may leaves; and also mixed with pigments to make the entire composition rich in tone and opaque in colour. Occasionally Hunt used layers of Chinese White as a primer on to which touches of pure colour might be stippled to gain even greater brilliance and luminosity.

Ruskin regarded Hunt as the best model to recommend to students of watercolour painting. 'Study the works of William Hunt', he commanded and: 'When you have time, practise the production of mixed tints by interlaced touches of the pure colours out of which they are formed, and use the process at the parts of your sketches where you wish to get rich and luscious effects.' The virtuosity of handling of Hunt's still-life and figurative watercolours was appreciated by subsequent generations of artists – Birket Foster and Fred Walker were amongst his greatest admirers – and he was the idol of the Victorian watercolour-collecting public. Towards the end of his life, however, he lamented: 'I still work hard at grapes and apples but I wish persons would like the drawings as bits of colour instead of something nice to eat.'

Hunt's ability to describe the literal appearance of his subjects appealed to an age of scientific investigation and classification. His still-lifes are extraordinary for their realism and accuracy; the varieties of his specimens, as well as their blemishes and imperfections, are minutely and conscientiously observed.

A not dissimilar spirit of exploration, although of a geographical and anthropological kind, pervaded the watercolour painting of John Frederick Lewis. His technical innovations were as remarkable as those of W. H. Hunt, and he was equally dependent on the use of bodycolour to manipulate the minute detail and to control the balance of light and shade. *Easter Day at Rome* (Plate 16) – the last watercolour he exhibited at the Old Water-

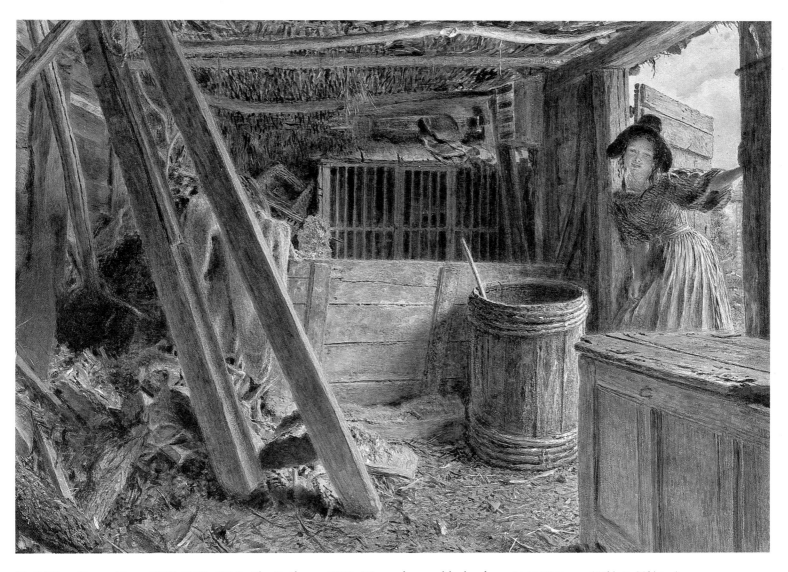

12. William Henry Hunt, OWS (1790–1864). *The Outhouse*, 1838. Watercolour and bodycolour, 54 × 74.9 cm. (21¼ × 29½ in.)
Cambridge, Fitzwilliam Museum

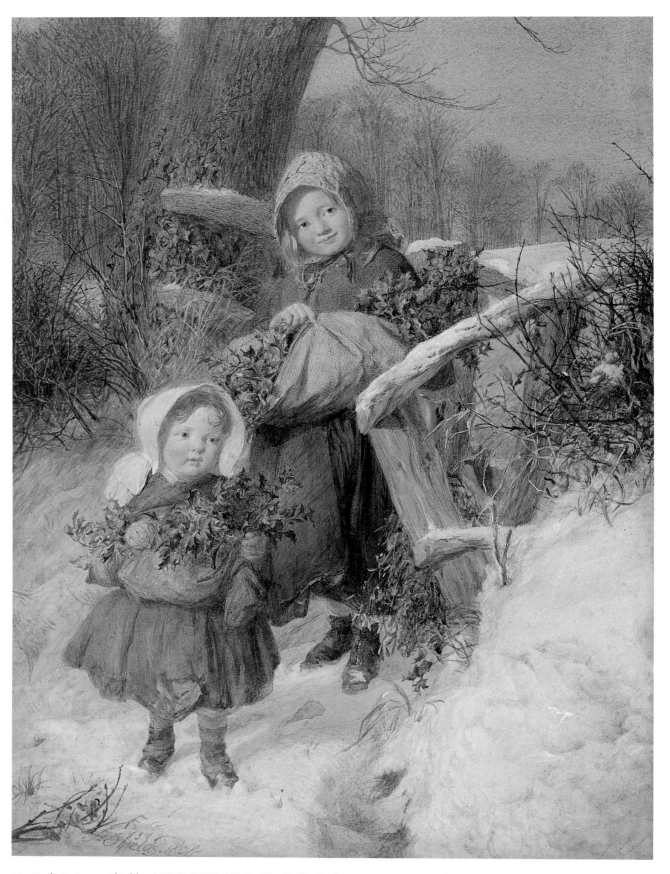

13. Frederic James Shields, ARWS (1833–1911). *The Holly Gatherers*, 1858. Watercolour and bodycolour, 48 × 33.6 cm. (18⅞ × 13¼ in.) University of Manchester, Whitworth Art Gallery

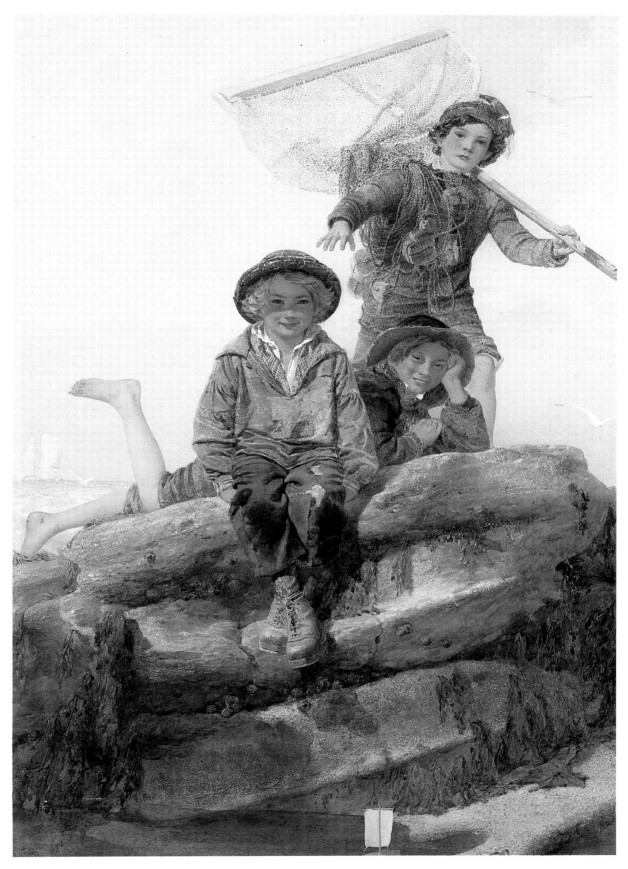

14. Alfred Downing Fripp, RWS (1822–1895). *Watching the Porpoises*, 1863. Watercolour, 58.4 × 41.6 cm. (23 × 16⅜ in.) London, Bethnal Green Museum

Colour Society prior to the ten years that he spent in voluntary exile from English artistic life – represents a departure from the conventions of early nineteenth-century watercolour painting. Vastly elaborate in its detail and complex in its variety of conflicting and subsidiary subjects, it was the consummation of Lewis's early career, and a fulfilment of the new criteria by which exhibited watercolours were judged.

J.F. Lewis left London for the East in 1840 and adopted the guise of an Ottoman aristocrat. Thackeray visited him in the Ezbekiya district of Cairo and described how he lived 'like a languid Lotus-eater – a dreamy, hazy, lazy, tobaccofied life. He was away from evening-parties, he said; he needn't wear white kid-gloves or starched neckcloths, or read a newspaper.' He lived in a 'long, queer, many-windowed, many-galleried house' with an 'open court with a covered gallery running along one side of it'. The unfinished *Courtyard of the Painter's House* (Plate 17) shows this princely residence.

Lewis was so long away and so completely out of touch, that in 1848 the Society withdrew his name from its list of members. However, when he began to exhibit the watercolours that he had painted in the East, or those that he worked up from sketches that he brought back to England, he caused a sensation. His works revealed a gorgeous and exotic world to a vastly intrigued public, and his ability to portray people and landscapes with the utmost naturalism met with a delighted response.

Amongst the most beautiful of all Victorian watercolours are the oriental interiors which Lewis painted. *Hhareem Life, Constantinople* (Plate 18) has a certainty of construction within the carefully measured perspectives of walls, window and upholstered bench which reminds one of the paintings of Vermeer. The psychological structure of the watercolour is as carefully controlled as its composition. The *Art Journal* described it at length on the occasion of its exhibition at the Old Water-Colour Society in 1857:

> two figures – one, the khanum, odalisque, or what you will, [who] reclines in a corner at the extremity of the divan, in the profound listlessness of oriental life. The casement is open, and she is playing with a cat, holding over it a feather-fan, from which the animal has torn portions of the feathers . . . The attendant stands in profile, being seen at half-length; and beyond her is hung a glass inclined forward, in which her head is repeated.

A motionless cycle of expectation is described: the cat languidly pauses before striking again at the fan; the mistress is distracted by her game from commanding the servant who awaits her pleasure; and outside the picture space another attendant, whose legs and feet only are visible in the looking glass, silently plays a part. 'That patience is inestimable', continued the *Art Journal*, 'which can execute the monotonous arabesque on the wall whereon the glass hangs, or even the shawl round the waist of the lady – the last touch as mechanically accurate as the first.'

Théophile Gautier, who admired Lewis's watercolours at the Paris Universal Exhibition of 1855, wrote: 'Mr Lewis combines chinese patience with persian delicacy in the execution of his silks and embroideries.' Lewis's oriental watercolours are the epitome of the mid-Victorian desire for apparently effortless finish and sumptuous richness of colour and tone. Commentators recognized the untold hours of laborious effort that went into them as well as the supreme technical skill.

The Victorian concept of pictorial realism was fulfilled and defined by the watercolours of William Henry Hunt and John Frederick Lewis. Although the urge to mirror nature was taken up by the Pre-Raphaelites, the works of Hunt and Lewis were never exceeded for their minute accuracy. Never before had artists so directly revealed their subjects to the scrutiny of the viewer, or so conscientiously addressed themselves to the process of that depiction.

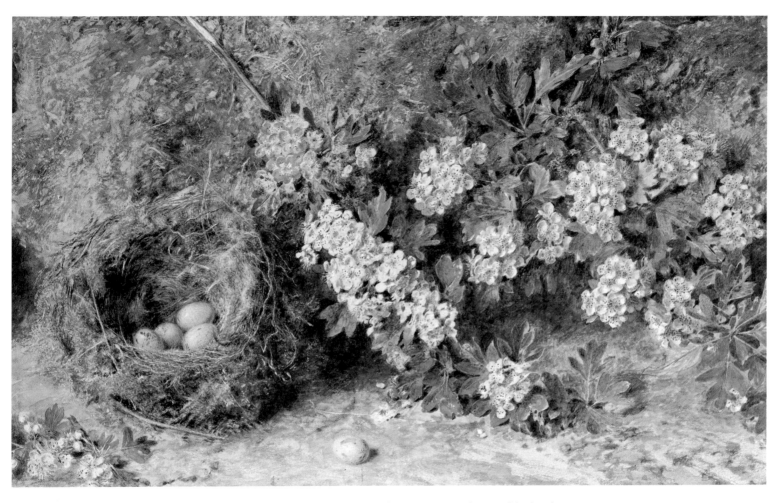

15. William Henry Hunt, OWS (1790–1864). *Chaffinch Nest and May Blossom*. Watercolour and bodycolour, 24.1 × 37.5 cm. (9½ × 14¾ in.) London, Courtauld Institute Galleries (Witt Collection)

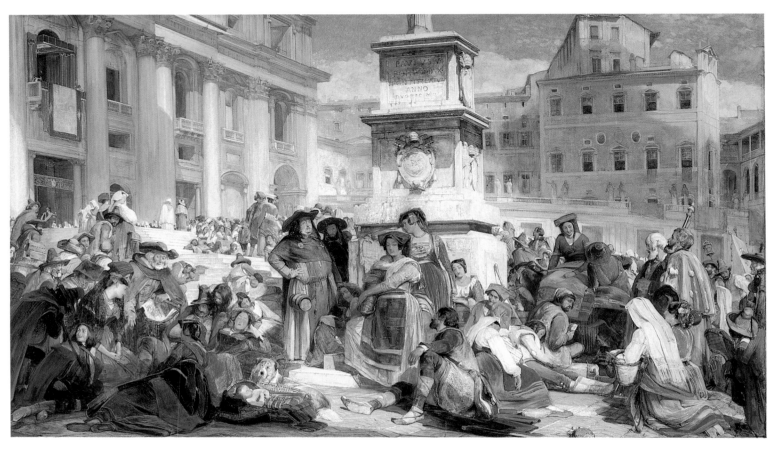

16. John Frederick Lewis, RA (1805–1876). *Easter Day at Rome*, 1840. Watercolour and bodycolour, 76.8 × 133.3 cm. (30¼ × 52½ in.) Sunderland Museum and Art Gallery

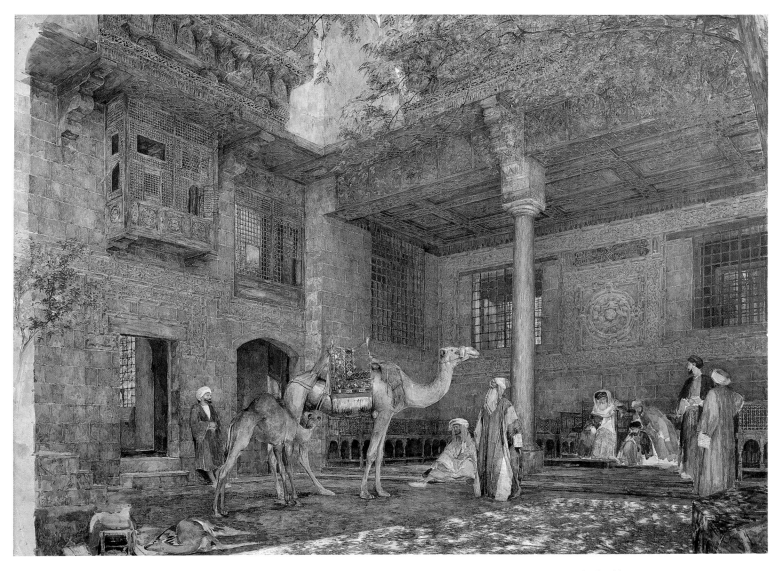

17. John Frederick Lewis, RA (1805–1876). *Courtyard of the Painter's House* (otherwise known as *The House of Shaikh Amin-Al-Suhaimi, Barb-Al-Asfar, Cairo*). Watercolour and bodycolour, 96.2 × 126 cm. (37⅞ × 49⅝ in.) Birmingham Museums and Art Gallery

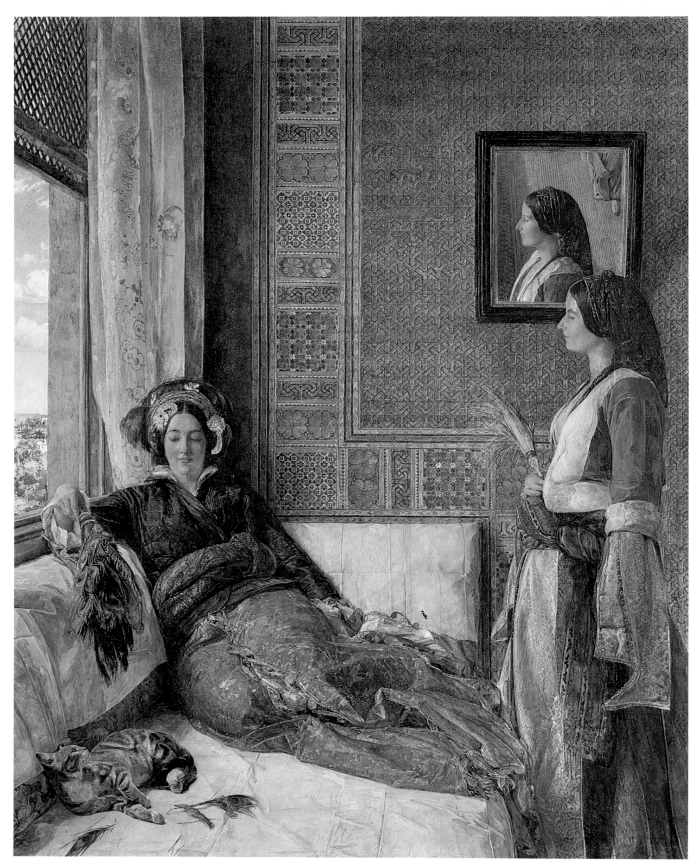

18. John Frederick Lewis, RA (1805–1876). *Hhareem Life, Constantinople*, exhibited 1857. Watercolour and bodycolour, 62.2 × 47.6 cm. (24½ × 18¾ in.) Newcastle-upon-Tyne, Laing Art Gallery

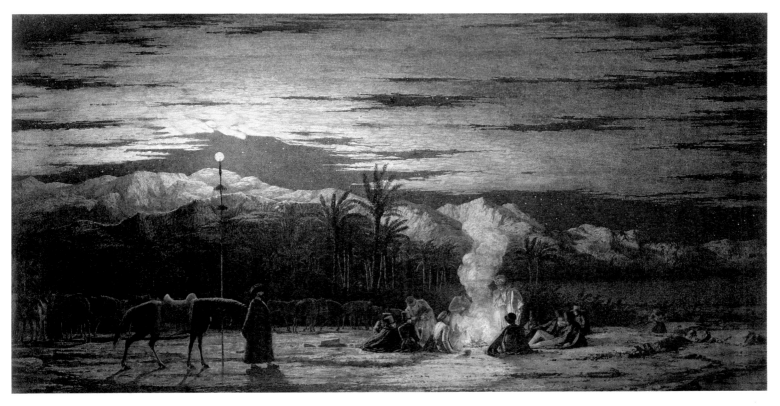

19. Richard Dadd (1817–1886). *The Artist's Halt in the Desert, c.* 1845. Watercolour and bodycolour, 37 × 70.7 cm. (14½ × 27¾ in.) Private collection

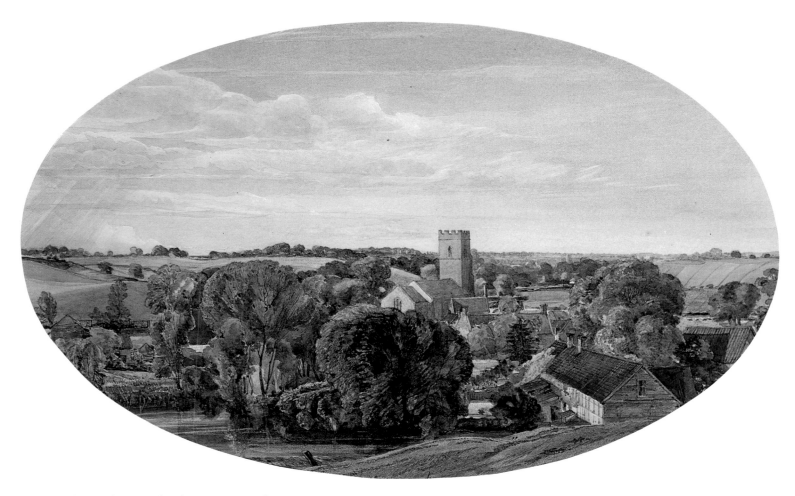

20. Anthony Frederick Augustus Sandys (1829–1904). *A Panoramic View of Hunworth*, *c.* 1850. Watercolour, 26.7 × 41.9 cm. (10½ × 16½ in.) Private collection

Richard Dadd's approach was different; he transcended conventional naturalism, and rather combined an occasionally frenzied imaginative approach with minutely observed realism. He sought obsessively to observe and record the actual and concrete appearance of things, perhaps as a means of defence against a threatening outside world. His works, even when apparently straightforward representations of places and people, must be seen in the context of his mental instability and eventual madness.

Dadd travelled to the Holy Land in the party of the Welsh lawyer Sir Thomas Phillips in 1842. David Roberts had recommended Dadd to the entourage on the grounds that 'the young artist's powers as a draughtsman, and his amiable qualities as a man, would render him as charming in companionship as he would be efficient as an artist.' Dadd described the arduous journey that Phillips's party made in exploration of the topography of the New Testament in a letter to William Powell Frith:

> We visited Nazareth, we saw the Sea of Galilee, we stayed at Tiberias, we sojourned at Carmel, we have seen the Holy City with all its sights, we have been to Bethlehem, and gone to Jericho, to the Jordan, the Dead Sea, and the convent of St. Saba, through the wild passes of Engaddi by moonlight.

His watercolour *The Artist's Halt in the Desert* (Plate 19) shows the party of European travellers, dressed in long coats or capes and wearing tall hats or caps, encamped close to the shores of the Dead Sea. In his letter to Frith, he told how the party was forced to wait for two hours for the moon to rise before proceeding by its light into the mountains. Of the Arab servants he noted: 'Their romantic, erratic, *latronatic*, Arabic character was much assisted by the fire round which we sat . . .'

In *The Artist's Halt* Dadd has transposed the traditional planar format and nocturnal luminosity of *The Flight into Egypt* as conceived by Adam Elsheimer in the early seventeenth century, to a secular and surreal purpose. Dadd's idiosyncratic watercolour technique, whereby areas of even colour are hatched with strokes of darker tone to give vibrant textures, was not conducive to literal representation. But the moonlit landscape and night sky which provide the setting for *The Artist's Halt* give a profound and timeless significance to the subject.

Frederick Sandys's *A Panoramic View of Hunworth* (Plate 20) was made as a record of a familiar locality at the request of a Norfolk naturalist and antiquarian, the Rev. James Bulwer. The simplicity of its composition reveals the affection for and patient observation of a particular place; the balance of its elements, and the opportunity provided by buildings in the foreground to lead the eye into the distance, are fortuitous rather than contrived. The technique, free of bodycolour or white highlights, is unspectacular but honest. The sensitivity of his adaptation of the East Anglian watercolour tradition of Cotman and Crome make Sandys's *View of Hunworth* a remarkable commencement in a career in which he only occasionally painted landscape subjects.

The 1840s were for watercolourists years of optimism and innovation. Progressive artists consistently sought greater naturalism in their works, and watercolours were judged by their degrees of realism. It was a period when ideas about the means and objectives of watercolour painting were being contested, and the diversity of its achievements reflected this debate.

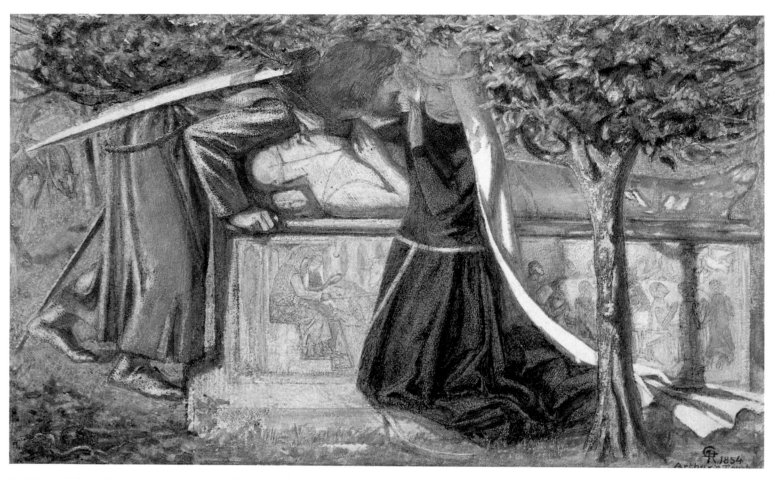

21. Dante Gabriel Rossetti (1828–1882). *Arthur's Tomb* (otherwise known as *Sir Launcelot parting from Guenevere*), 1854. Watercolour, 22.9 × 36.8 cm. (9 × 14½ in.) London, British Museum

The year 1848, when political upheaval and revolution reverberated through Europe, marked the commencement of an important era in English art: a ferment of new ideas about painting, and a spirit of self-reliance and a belief in the possibility of change, led in that year to the formation of the Pre-Raphaelite Brotherhood.

What at first may have seemed an obscure and forlorn faction within the wide spectrum of English painting resulted in its successive phases in an artistic reformation, first in the interests of realism and objectivity, and later in the expression of an intense and compelling romanticism. For twenty years the principal painters of this curiously named group, John Everett Millais, William Holman Hunt and Dante Gabriel Rossetti, were central to the advancement of English art. The aims of the movement were adapted by many later painters – sometimes to conflicting and contradictory purposes – and remained current until the end of the Victorian age.

The multitudinous forms which Pre-Raphaelitism took were echoed and inspired by John Ruskin, who became the principal theorist and advocate of the movement. The five volumes of *Modern Painters*, begun as a defence of Turner's painting and published between 1843 and 1860, contain general analyses of artistic principles and objectives as well as Ruskin's heartfelt admonitions to contemporary artists. He pleaded that they 'should go to Nature in all singleness of heart, and walk with her laboriously and trustingly, having no other thoughts but how best to penetrate her meaning, and remember her instruction; rejecting nothing, selecting nothing, and scorning nothing; believing all things to be right and good, and rejoicing always in the truth.' The wider context of Ruskin's ordinance makes clear that this apprenticeship to Nature should be a formative training for all painters, rather than simply a code for landscape painters. The less familiar words that concluded the first volume were:

> Then, when their memories are stored, and their imaginations fed, and their hands firm, let them take up the scarlet and the gold, give the reins to their fancy, and show us what their heads are made of. . . . They have placed themselves above our criticism, and we will listen to their words in all faith and humility; but not unless they themselves have before bowed, in the same submission, to a higher Authority and Master.

Of the three principal members of the Brotherhood only Rossetti was primarily a watercolourist. Millais used watercolour for illustrations and studies but considered oil, which he handled with great virtuosity, more appropriate for finished paintings. Holman Hunt painted brilliant landscapes in watercolour.

In the overall context of Pre-Raphaelitism the advocates of watercolour shared the belief that the medium was appropriate to all categories of subject, including that which academical theory and Ruskin considered the highest in value and importance: namely the Bible, mythology, literature and history painting. Pre-Raphaelite figurative watercolours, whether based on literary imaginings or historical fact, are concerned with the emotions. The scenes of confrontation and separation, and the moods of happiness and despair, are depicted with dramatic

force and were subjects deeply felt by those who painted them. They were the fulfilment of Ruskin's belief that artists should go beyond dutiful naturalism to themes in which they might exercise their imaginations to explore and describe human passions and predicaments.

Rossetti, who had previously struggled to master the techniques of oil painting, began in the early 1850s to explore the possibilities of painting ornate and richly coloured watercolours in which he might express his romantic fascination with the Middle Ages. He immersed himself in the literature which described the fantastic and ritualized events of medieval history, and was particularly drawn to Malory's *Morte d'Arthur*, which made a vast impression on the artist's febrile imagination.

Arthur's Tomb (Plate 21) was the first of his series of Arthurian subjects. It describes by the concerted means of compositional drama and complex symbolism the tragic meeting of Queen Guenevere and Sir Launcelot after the death of King Arthur. Guenevere, in her mortification, refuses Launcelot a last kiss.

Medievalism and the *Morte d'Arthur* linked the group of artists who set the pattern for the second impulse of the Pre-Raphaelite movement. Edward Burne-Jones and his friend William Morris regarded the book as 'one of their most precious treasures: so precious that even among their intimates there was some shyness over it, till a year later they heard Rossetti speak of it and the Bible as the two greatest books in the world, and their tongues were unloosed by the sanction of his authority.'

The most elegant watercolour to be inspired by the *Morte d'Arthur* was Burne-Jones's *Green Summer* (Plate 23); although the subject of the watercolour was thematic rather than documentary, the title echoes a passage in Malory's poem where 'true love is likened to summer' and which tells how 'winter rasure doth always erase and deface green summer, so fareth it by unstable love in man and woman.'

The picture evokes a mood of tranquil absorption by, and meditation upon, the words of poetry that are being read. Seven women, draped in green and sitting in a wooded landscape, are listening to an eighth figure, who is dressed in black. Little more can be said about the actual subject; a calm and restful air seems to pervade the scene which was described by Burne-Jones's painter friend Edward Clifford as 'the flower and quintessence of summer'. However, the sentiment of the watercolour is equivocal. Burne-Jones subtly evoked the true gist of Malory's verses and introduced a mood of wistful regret for the passing of summer days.

Green Summer combines the calm and balance of classical sculpture with the decorous elegance and concealed emotion of Giorgione's paintings. The quality of its construction, in its figurative elements and draperies, and its landscape and atmosphere, and the simple yet mysterious subject which it describes, make it both a beautiful and disturbing watercolour. Burne-Jones painted *Green Summer* in 1864 at a time in his life when he had many reasons to be happy. He was recently married (the female figures in the watercolour are loosely modelled on his wife Georgiana, her sisters, and other friends of theirs, including Jane Morris), and his election to the Old Water-Colour Society at least indicated that he was gaining renown as a painter. He exhibited the picture at the Society a year later and it is perhaps true to say that no more original or challenging watercolour was ever shown there.

In their treatment of literary, biblical or mythological subjects the Pre-Raphaelites placed great importance on the careful representation of setting and incidental detail, as well as on the dramatic action described in the original text.

Both detail and emotional drama are important in Ford Madox Brown's *Elijah and the Widow's Son* (Plate 22). The event is taken from the Book of Kings I in the Old Testament where the Prophet brings back to life a young boy. When Brown exhibited the oil version in 1865 he gave a long account of the significance and symbolism of the different parts of the composition. He described how he had carefully researched the grave-clothes and floral adornments of the child, 'without [which], the subject (the coming to life) could not be expressed

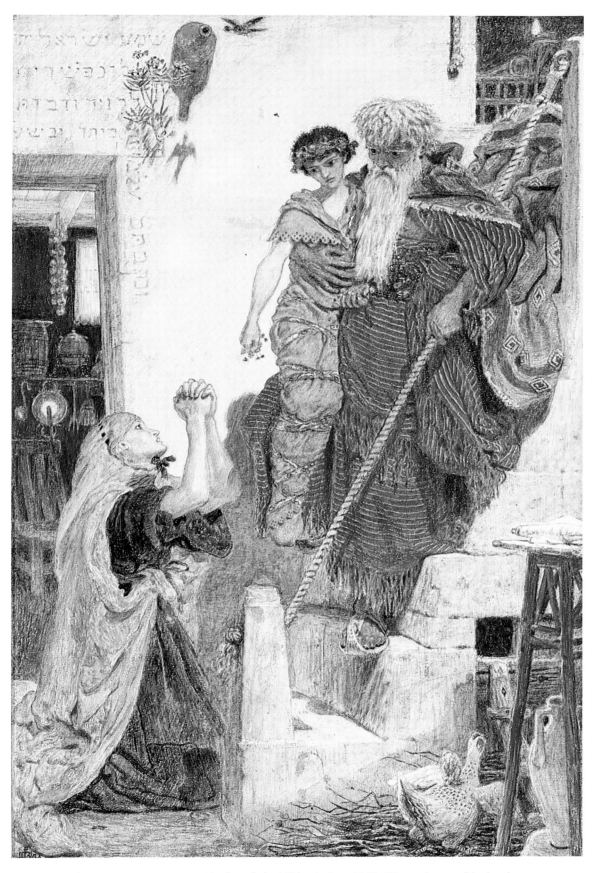

22. Ford Madox Brown (1821–1893). *Elijah and the Widow's Son*, 1864. Watercolour and bodycolour, heightened with gum arabic, 39.4 × 25.4 cm. (15½ × 10 in.) Private collection

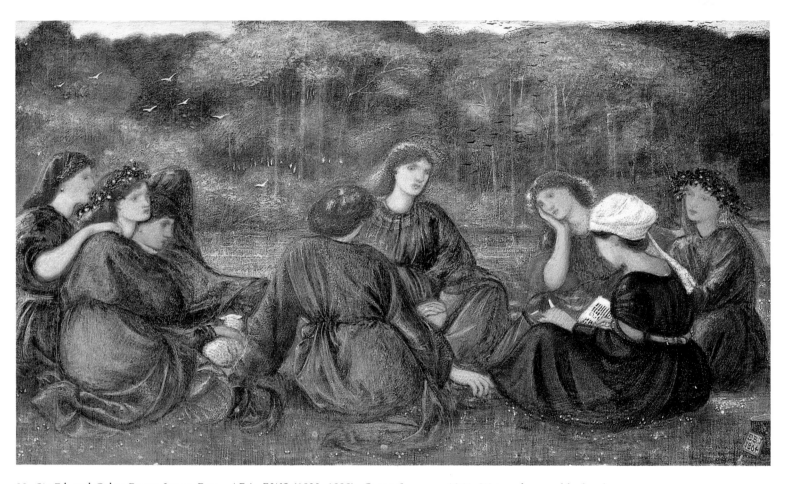

23. Sir Edward Coley Burne-Jones, Bart., ARA, RWS (1833–1898). *Green Summer*, 1864. Watercolour and bodycolour, 28.9 × 48.3 cm. (11⅜ × 19 in.) Private collection

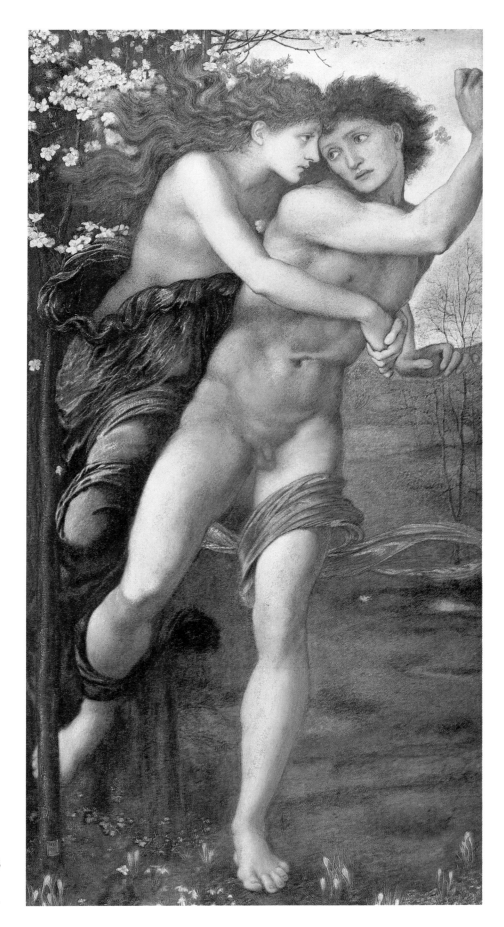

24. Sir Edward Coley Burne-Jones, Bart., ARA, RWS
(1833–1898). *Phyllis and Demophoön*, 1870.
Watercolour and bodycolour, 91.4 × 45.7 cm.
(36 × 18 in.) Birmingham Museums and Art Gallery

by the painter's art'. The bird returning to its nest – 'consisting of the bottle which in some countries is inserted in the walls to secure the presence of the swallow of good omen' – was a symbol of the return of the child's soul. Further account is given of the Hebraic inscriptions over the door, the widow's costume and the preparations which she has been making for the Prophet's supper. No element is unconsidered or left to chance and herein lies a clue to the diligence and commitment of Pre-Raphaelite painters to the means by which a story might be told.

Ford Madox Brown had been commissioned to prepare an illustration of *Elijah and the Widow's Son* for Dalziel's *Bible Gallery*, which was to consist of a volume of plates of biblical subjects. The fact that he then proceeded to work up oil and watercolour versions of the composition was because of the value and importance that he attached to his pictorial solution to the difficulties of describing the scene, rather than because of any particular demand for religious subjects. Christian iconography was familiar to a wide audience and many Victorians were intrigued by the parallels between events in the Old and New Testaments. However, Victorian watercolours were seldom adapted to a didactic purpose, and moral or religious instruction rarely obtruded.

Mythological subjects were similarly appreciated by those for whom the events and characters of Greek and Roman mythology were recognizable or familiar. The appeal of such themes was enhanced by the mood of religious scepticism current during the second half of the century, and by the new agnosticism in artistic and literary circles.

Burne-Jones took the subject of *Phyllis and Demophoön* (Plate 24) from the *Heroides* of Ovid. He depicts the moment when Demophoön embraces the barren almond tree into which his lover Phyllis, the Queen of Thrace, has been transformed, and blossom springs from its branches. Burne-Jones treated the theme of the sad consequences of mismatched love at a time when his own emotions were in disarray. The model for Phyllis was a girl called Maria Zambaco, with whom he was deeply in love.

Burne-Jones's decision to exhibit *Phyllis and Demophoön* at the Old Water-Colour Society led to a crisis when objection was made to the nudity of the male figure. He withdrew the watercolour from the exhibition and resigned his membership. In the conservative opinion of most fellow-painters and of a large proportion of the gallery-going public, Burne-Jones's watercolours were technically aberrant and obscure in subject. In 1865 the *Art Journal* had expressed the majority's view when a reviewer wrote: 'At the outset we confess ourselves one of the uninitiate multitude who are wholly unworthy of the rare revelation of which Mr. Jones is the favoured recipient.' Burne-Jones was hurt by the philistine ridicule with which his mythological watercolours were met and from 1873 to 1877 he withdrew from public artistic life.

Victorian watercolour painting aroused strong feelings, both enthusiastic and indignant, amongst a wide community. Rossetti was so contemptuous of public opinion that he never allowed his works to be exhibited. In general, the watercolours of historical subjects painted by Rossetti, and by Ford Madox Brown and Burne-Jones, were relatively little known beyond the immediate circle of friends and sympathisers that attached itself to the Pre-Raphaelite movement. Their esoteric nature had limited appeal; and their inconsistent moral tone disconcerted the sense of probity of the Victorian middle classes.

However, the Pre-Raphaelites shared a more general Victorian preoccupation with the patterns of their own lives, and believed that the contemporary scene and setting was a fit subject for painting. The scenes of modern life and the views of urban and rural landscapes which they depicted are as important and original as their historical and literary subjects. For the first time, the inconsequential events and feelings of ordinary people were considered worthy of record.

Rossetti's *Writing on the Sand* (Plate 25) was a heartfelt and personal soliloquy on the theme of romantic love. A young couple are represented walking hand in hand on a beach in summer. It is unique amongst Rossetti's watercolours in showing figures in contemporary dress; the girl wears a black shawl, in which she has folded a

25. Dante Gabriel Rossetti (1828–1882). *Writing on the Sand*, 1859. Watercolour and bodycolour, 26.7 × 24.2 cm. (10½ × 9½ in.)
London, British Museum

straw hat, and a blue skirt, and her crinoline petticoat is momentarily exposed by a gust of wind. She watches with passive demeanour as her companion draws her portrait in the sand. Rossetti painted the watercolour for a beautiful young actress called Ruth Herbert whom he admired. It is possible that the girl has been given her features; he perhaps identified with the young man who, tongue-tied and bashful, has found an ingenious means of expressing his infatuation.

Rossetti had difficulties with the background of *Writing on the Sand* and sought advice from a landscape artist. His friend George Price Boyce wrote in his diary: 'Rossetti called and borrowed 2 sketches of mine on the coast of Babbacombe as a help to background of a delicate little drawing of a loving couple on a sea beach on a windy day he is doing for Miss Herbert.'

Burne-Jones seldom painted landscape for its own sake, but occasionally made studies from which he could work up landscape details in his figurative subjects. His *Landscape with Willows and Poplars* (Plate 26) was a preparatory sketch for *Green Summer*.

However, the genre of landscape painting was an important one for many Pre-Raphaelite watercolourists. Views of the outside world, whether they show an inhabited environment or scenery unmarked by man, reveal the excitement that painters felt about their surroundings. Dadd and Lewis had painted oriental subjects because they were attracted by the life that was led in the cities and deserts of the Middle East, and shared the romantic fascination that this exotic world held for European imaginations. The Pre-Raphaelites who travelled to the Holy Land did so with the self-conscious objectives of studying the biblical history of its landscape. For Holman Hunt, who dismissed J.F. Lewis as 'the painter of Egyptian social scenes', the purpose of painting in the East was to give an archaeological and symbolic record of the hallowed places of the Bible and to provide material for Christians meditating on the events of the Old and New Testaments.

In *The Plain of Rephaim from Mount Zion* (Plate 27) Holman Hunt has given both coded and apparent information about the historical importance of the landscape. He included in the foreground the figure of a man who shields two children from stone-throwing boys, a detail which has been interpreted as a symbol of King David's defence of the Children of Israel. Thus a rhapsodic account of a mountainous and desert landscape was turned into a metaphor of biblical history. The vantage-point from which he studied the panorama of the Plain of Rephaim was on Mount Zion, close to the site of The Last Supper. The stupendous colours of the landscape; the brilliant yellows and greens of scrubby vegetation against the burnt umbers and oranges of the arid countryside, the long purple shadows of the distances, and the brightly sunlit foreground, recall the profound impression that the beauty of the scene had made on him.

Holman Hunt had travelled from London to Cairo in 1854 to join his friend Thomas Seddon. The two painters worked together; Hunt prohibited Seddon from sketching, but introduced him to the Pre-Raphaelite method of painting finished watercolours direct from the study of landscape.

Seddon shared Hunt's belief in the mystical importance of the biblical landscape. In Jerusalem, to which place the two travelled in June, Seddon felt that he was 'treading upon holy ground'. When he returned to Europe in October 1854 he had completed a superb oil of Jerusalem (Tate Gallery) and several watercolours of the city and its environs. In *The Hills of Moab* (Plate 28) he has observed the moment when the shadowed valley became immersed in penumbral purple: the sky beyond the distant hills, which are seen in the direct light of the setting sun, is a strange green; the impression is one of a landscape weirdly transformed by the effect of vespertine light.

The interest that Pre-Raphaelite watercolourists took in the events of modern life was spurred by the exodus of population from the countryside and the consequent expansion of the towns and cities. Both rural and urban landscapes were painted; the former in a spirit of determined rejection of city life and urbanization; the latter as a record of the surroundings in which the majority had their existence.

26. Sir Edward Coley Burne-Jones, Bart., ARA, RWS (1833–1898). *Landscape with Willows and Poplars, c.* 1864. Watercolour and bodycolour, 19.3 × 43.2 cm. (7⅝ × 17 in.) Birmingham Museums and Art Gallery

27. William Holman Hunt, OM, RWS (1827–1910). *The Plain of Rephaim from Mount Zion*, 1855. Watercolour and bodycolour, 35.6 × 50.8 cm. (14 × 20 in.) University of Manchester, Whitworth Art Gallery

28. Thomas Seddon (1821–1856). *The Hills of Moab and the Valley of Hinnom, c.* 1854. Watercolour and bodycolour,
30.3 × 22.9 cm. (11⅞ × 9 in.) Oxford, Ashmolean Museum

29. Ford Madox Brown (1821–1893). *Hampstead – A Sketch from Nature* (otherwise known as *Hampstead from my Window*), 1857. Watercolour, 14 × 22.9 cm. (5½ × 9 in.) Delaware Art Museum, Mary R. Bancroft Memorial

30. Albert Joseph Moore, ARWS (1841–1893). *Study of an Ash Trunk*, 1857. Watercolour and bodycolour, heightened with gum arabic, 30.3 × 22.9 cm. (11⅞ × 9 in.) Oxford, Ashmolean Museum

31. John Ruskin, HRWS (1819–1900). *In the Pass of Killiecrankie*, 1857. Watercolour and bodycolour, with pencil and ink, 28.2 × 24.8 cm. (11⅛ × 9¾ in.) Cambridge, Fitzwilliam Museum

In *Hampstead – A Sketch from Nature* (Plate 29) Ford Madox Brown brought Pre-Raphaelite intensity of colour and meticulous detail to bear on the verdure of the salubrious suburb, as it appeared from his own house in Kentish Town. When Ruskin inquired of Brown's *An English Autumn Afternoon* (Birmingham Museums and Art Gallery), which is an oil counterpart to the watercolour, 'What made you take such a very ugly subject [?]', Brown stubbornly replied 'Because it lay out of a back window.' In this response to Ruskin's provocation Brown was insisting on the usefulness of painting scenes the very significance of which lay in their familiarity to the Victorian middle-class families who lived in the once countrified villages of North London.

Brown did not arrange the composition of his watercolour, which is also known by the title *Hampstead from my Window*. The relatively high viewpoint allows a partly obscured but intriguing perspective of Hampstead, the parish church of which is seen beyond the expanse of Hampstead Heath. Buildings and trees in the foreground conceal the depths of the landscape from view, and are broken by the edges of the composition. Overlapping screens of contrasting texture and substance make up the dense and crowded subject.

The precepts and technical devices of Pre-Raphaelite watercolourists were perhaps most completely demonstrated in the pure landscapes they painted. Ruskin paid homage to the laws of Nature by investigating the precise botanical and geological character of materials. In *The Elements of Drawing* he described some of the types of landscape which he most enjoyed, and which he felt would repay students of watercolour:

> In general, all banks are beautiful things, and will reward work better than large landscapes. If you live in a lowland country, you must look for places where the ground is broken to the river's edges, with decayed posts, or roots of trees; . . . Nearly every other mile of road in chalk country will present beautiful bits of broken bank at its sides; better in form and colour than high chalk cliffs. In woods, one or two trunks, with the flowery ground below, are at once the richest and easiest kind of study: a not very thick trunk, say nine inches or a foot in diameter, with ivy running up it sparingly, is an easy, and always a rewarding subject.

Ruskin created a type of watercolour which described a face of the countryside which a naturalist or painter might discover if he explored on his hands and knees. His studies of lichenous rock and invading vegetation are without human or topographical references. The drama of his compositions derives from the elemental forces which constantly break down and reconstitute the physical landscape.

In the Pass of Killiecrankie (Plate 31) offers only a glimpse of a more distant landscape and horizon. Practically no orientation to the outside world is permitted, and only the surface of water in the immediate foreground allows the viewer to reckon the angle and range of vision. The eye is forced to explore the torn face of rock and encroaching heather, which make a dense and almost abstract pattern in Ruskin's pictorial form.

In the late 1850s, and particularly following the publication of *The Elements of Drawing* in 1857, many watercolourists painted minute studies of landscape. For example, Albert Moore, a painter who had no connections with the Pre-Raphaelite circle, painted *Study of an Ash Trunk* (Plate 30), a watercolour which has been described as 'a study of foliage as microscopically close as anything done in the Pre-Raphaelite sphere'. The correspondence between Ruskin's suggestions as to landscape subjects and the young Moore's watercolour is clear.

The intent devotion with which watercolourists scrutinized the countenance of nature is a measure of the originality of the Pre-Raphaelites. The spirit of inquiry and the search for information about the world around them were characteristic of a generation who questioned both the scientific and the artistic basis of man's most fundamental relation with nature. Watercolourists were forced to search for new technical means to satisfy their urge to record the appearance of things with the utmost realism, and came to see the physical world, either by direct observation or through the medium of their imaginations, with fresh eyes. Pre-Raphaelite watercolours reflect the objectivity and immediacy of that vision.

Du uring the later 1850s and 1860s Pre-Raphaelitism became the dominant style of painting amongst landscape painters. Many of the watercolourists who adopted the detailed and brightly coloured representation of specific and closely observed subjects were friends of the members of the Pre-Raphaelite Brotherhood, but some had had no contact with the original protagonists and joined the movement by a process of stylistic osmosis. Roget wrote of the years of J.F. Lewis's presidency of the Old Water-Colour Society, 1855–8:

> The larger style of composition practised by the earlier artists was becoming less of an aim to a new generation brought up under the teaching of Ruskin and impressed by the doctrines of the pre-Raphaelite school. In its place a minutely realistic imitation of nature was now upheld as a nobler object of ambition.

Pre-Raphaelite landscape painting took for its principal subject-matter the range of natural phenomena: mountains and hillsides and their geological constructions; rivers and streams and the flow of water; and lowland landscapes rich in woodland and flowers.

The countryside was a place of retreat for Victorian artists; landscape watercolourists often spent the summer making sketches from which finished works could be built up, or working on more elaborate subjects in the open air. Amongst the favourite sketching-grounds were Bettws-y-Coed in Wales and Brignal Banks in Yorkshire. Other more solitary artists explored the landscape on their own, staying at wayside inns or in rented cottages. Successful watercolourists, like Birket Foster, bought or built country houses and invited their artist friends to stay, or even persuaded them to move close by to form artists' communities.

Many artists worked in the open air and experienced the sensations of landscape directly. In 1866 the *Art Journal* commended 'the growing habit of painting out of doors; hence the open daylight, the sunshine, and even the breeze now brought within a picture'. However, while a sense of atmosphere was valued, transient effects of weather were not allowed to mask the physical characteristics of the scenery. Bright light and clear distances, in which the utmost definition was allowed, are the common climatic conditions of the Pre-Raphaelite landscape.

Barbara Bodichon's *Ventnor, Isle of Wight* (Plate 32), exceptional in its scale and vigorous technique, was exhibited at the Royal Academy in 1856 where it was described by William Michael Rossetti as 'full of *real* Pre-Raphaelitism, that is to say, full of character and naturalism in the *detail*'.

This epic adaptation of Pre-Raphaelite technique was the work of a most remarkable and formidable woman. Bodichon was a campaigner for women's rights and co-founder of Girton College, Cambridge, as well as an amateur painter and much-loved friend of artists. D.G. Rossetti described her in 1854 as 'blessed with large rations of tin [money], fat, enthusiasm and golden hair, who thinks nothing of climbing up a mountain in breeches, or wading though a stream in none, in the sacred name of pigment'.

As a painter Bodichon preferred wild and uninhabited landscapes. Ruskin tried to direct her towards architectural subjects, but despaired of her as a pupil when her search for scenery untouched by man took her to the swamp country of Louisiana which, she wrote, was 'a new revelation of nature's beauty'.

William Bell Scott was an ambitious painter and poet on the fringe of the Pre-Raphaelite group. Although he had questioned the value of Ruskin's advice to landscape painters in *The Elements of Drawing* Scott often took subjects of the kind that Ruskin recommended. In *Landscape with a Gate and Watermeadow* (Plate 33) he has looked downwards into the watery foreground of a pond: the brilliant greens of the fringe of reeds and grass and the reflections of the sky in its surface are illuminated by the dazzling sunlight. The elements of the composition are crammed into a tight pictorial space; the gate post that is seen in raking light is forced to the left-hand margin and the tree breaks out of the top edge of the picture space.

George Price Boyce's watercolours, like those of Scott, represent an extreme reaction against a landscape tradition which accepted the picturesque grouping of familiar or predictable elements for pretty effects. They were admired and recognized as extraordinary by his contemporaries, including Boyce's friend Rossetti. In *Black Poplars at Pangbourne* (Plate 36) Boyce chose a vantage-point which would ensure that the foliage of the trees and vegetation of the foreground would assume a composition of near abstraction. The subject – the meadows and woodland beside the Thames – is reduced into dense superimposed layers of green. No view beyond the successive screens of reed-beds, oak saplings and poplars is permitted. Glimpses only are given of buildings and cattle amongst the trees, and the parapet of a bridge on the right-hand side of the composition is the only clue to the course of the river. In the foreground moorhens are pursued by a bounding spaniel.

Boyce delighted to paint scenes which, although unremarkable in themselves, become strange and fascinating because of his choice of unexpected and often problematic viewpoints and lines of perspective; timeworn buildings and full-leafed trees are seen in intriguing conjunctions, or masked or partly obscured by vegetation. These idiosyncratic methods, as well as a colour range of foliate greens and the reds of bricks and tiles, make Boyce's watercolours distinctive and beautiful.

According to the *Art Journal* in 1860 Birket Foster's 'water-colour drawings must be classed with the Pre-Raffaellite school . . .'; indeed, he was a watercolourist who combined progressive and traditional methods. His classic evocations of the English countryside, such as *The Thames from Cliveden* (Plate 35), contain vibrant colours unified and made tonally harmonious by the virtuosity of his stippled bodycolour technique. However, compared with the works of younger watercolourists like G.P. Boyce and A.W. Hunt, Birket Foster's vision of landscape seems stilted and done according to preconceived formulae rather than observation. Foster borrowed from the repertoire of romantic painting the device of framing the composition with trees (seen previously in Samuel Palmer's *Landscape with Windmill,* Plate 10), and the precipitous perspective down to the Thames and the atmospheric effects of drifting smoke and distant haze are derived from Turner. Admirable though *The Thames from Cliveden* is as a watercolour, little sense is given of the artist's own feeling of delight to have found himself in such an idyllic place.

Ruskin had inculcated a sense of the importance of recording the findings of searching inquiry about the physical world into the hearts and minds of many younger painters. Amongst those who served a temporary apprenticeship to the great man was Albert Goodwin. Ruskin took Goodwin to the Alps and Venice in 1872 and the young artist was encouraged and commissioned to paint the types of architectural and landscape subjects of which Ruskin approved. Ruskin's fondness for the Italian landscape is perhaps reflected in Goodwin's watercolour *Certosa, near Florence* (Plate 37), which shows the monastery bathed in the last rays of the setting sun and the spacious valley in the blue light of dusk.

More essentially Ruskinian is Goodwin's *Old Mill, near Winchester* (Plate 34). Here the artist has

32. Barbara Bodichon (1827–1891). *Ventnor, Isle of Wight*, 1856. Watercolour and bodycolour, 71.1 × 108 cm. (28 × 42½ in.)
Private collection

33. William Bell Scott (1811–1890). *Landscape with a Gate and Watermeadow*, 1865. Watercolour and bodycolour, 25 × 35.2 cm. (9⅞ × 13⅞ in.) Maidstone Museum and Art Gallery

34. Albert Goodwin, RWS (1845–1932). *Old Mill, near Winchester*, 1875. Watercolour and bodycolour, with ink drawing, 22.2 × 31.7 cm. (8¾ × 12½ in.) Collection of Dr Chris Beetles

35. Myles Birket Foster, RWS (1825–1899). *The Thames from Cliveden.* Watercolour and bodycolour, with scratching out, 34.3 × 71.1 cm. (13½ × 28 in.) London, British Museum

36. George Price Boyce, RWS (1826–1897). *Black Poplars at Pangbourne,* 1868. Watercolour, 36.8 × 53.3 cm. (14½ × 21 in.) Collection of Christopher Newall

patiently documented a view into the shallow depths of a mill-stream and lovingly studied the construction of the walls and roofs of the various mill buildings. Nothing about the subject has been assumed; every element has been carefully observed. Goodwin accepted Ruskin's ethos that landscape painters should search for complete truths on the basis of their view of the physical world, rather than allow their perceptions to become diffused into generalized or decorative evocations. At this early stage of his career Goodwin held objectivity more highly than mere gratification of the eye.

Through the middle years of the century the lessons that had been learnt from Pre-Raphaelitism were applied to different types of landscape painting, and more and more frequently by artists who had no direct connection with the Brotherhood or with Ruskin. Pre-Raphaelite technique was adapted by various watercolourists who specialized in woodland scenes, which were popular in the exhibitions of the 1860s. Two charming studies of children at play in woodland settings, 'Rest in the cool and shady Wood' (Plate 40) by Edmund George Warren and 'Hide and Seek' (Plate 39) by George Shalders, represent this specialization. Warren and Shalders departed from the technical requirements of Pre-Raphaelitism by using repeated touches of the same opaque colours over wide areas of their compositions, rather than observing and meticulously matching the different colours in nature as Ruskin insisted landscape painters should do.

In *Academy Notes* (1859) Ruskin described two of Warren's watercolours as 'good instances of deceptive painting – scene-painting on a small scale – the treatment of the light through the leaf interstices being skilfully correspondent with photographic effects. There is no refined work or feeling in them, but they are careful and ingenious; and their webs of leafage are pleasant fly-traps to draw public attention.' The same criticism would apply to 'Rest in the cool and shady wood'.

Richard Redgrave's *Parkhurst Woods, Abinger* (Plate 38) is a delightful view of the floor of a beechwood, where a child sits gazing out at the spectator. The Pre-Raphaelite fondness for the ancient woodlands of Surrey and Kent, previously expressed in oil by Holman Hunt, is recalled in this simple but inviting watercolour.

Birket Foster's watercolours of figures, usually children, seen in a pleasant if untidy open-air setting, mark a further stage in the process by which landscape painting became a vehicle for sentimental domestic and genre subjects. In *Lane Scene at Hambleden* (Plate 41) the artist has found a mother and children for his models. Birket Foster created in his watercolours of rustic life, of which *Lane Scene at Hambleden* is a quintessential example, a vision of the countryside as it never was, but nevertheless one which provided town and country dwellers with an enduring image of the rural landscape of a mythical past.

When artifice rather than observation determined the composition of watercolours, and the handling and use of colour derived from a formula rather than a passionate belief in truth to nature, Pre-Raphaelitism became disingenuous and vulgarized. However, when the landscape painters of the 1850s and 1860s combined detailed views with the more mysterious sense of the uniqueness of a specific place, they provide a vision of an undisturbed landscape only accessible or capable of being explored through its record in watercolour.

Watercolour was often used for topographical and architectural subjects. The medium was prized for its practical qualities by professional and amateur painters who wished to record buildings and architectural detail as well as views of their rural or urban settings.

Alfred William Hunt's *Finchale Priory* (Plate 43) and Henry George Hine's *Amberley Castle* (Plate 42) both show a timeworn and overgrown relic of architecture in the English countryside seen in the flush of early summer. Each painter has given a distant and more calmly balanced view of the scenery than Pre-Raphaelite precedent suggested. Hunt's subject provides a minute account of the woodland around Finchale Priory and beyond on the bank of the escarpment above the River Wear. Hine has allowed a more spacious view of the

37. Albert Goodwin, RWS (1845–1932). *Certosa, near Florence*, 1873. Watercolour, 49.5 × 72.4 cm. (19½ × 28½ in.)
Private collection

38. Richard Redgrave, RA (1804–1888). *Parkhurst Woods, Abinger*, 1865. Watercolour and bodycolour, 25.4 × 38.1 cm. (10 × 15 in.) London, Victoria and Albert Museum

39. George Shalders (1826–1873). *'Hide and Seek'*. Watercolour and bodycolour, heightened with gum arabic, 29.8 × 35.3 cm. (11¾ × 13⅞ in.) Collection of Mr and Mrs Michael Bryan

40. Edmund George Warren, RI (1834–1909). *'Rest in the cool and shady Wood'*, 1861. Watercolour and bodycolour, heightened with gum arabic, 77.5 × 120.3 cm. (30½ × 47⅜ in.) London, Bethnal Green Museum

41. Myles Birket Foster, RWS (1825–1899). *Lane Scene at Hambleden*, exhibited 1862. Watercolour and bodycolour, 42.5 × 63.5 cm. (16¾ × 25 in.) London, Tate Gallery

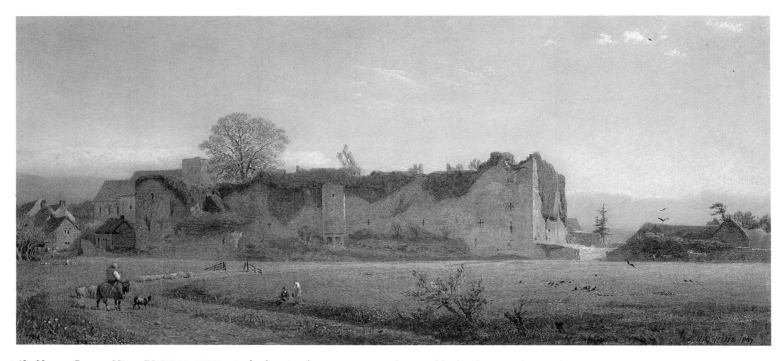

42. Henry George Hine, RI (1811–1895). *Amberley Castle*, 1867. Watercolour and bodycolour, with scratching out, 26 × 57.2 cm. (10¼ × 22½ in.) Collection of Christopher Newall

43. Alfred William Hunt, RWS (1830–1896). *Finchale Priory*, exhibited 1862. Watercolour and bodycolour, with scratching out, 32.4 × 48.3 cm. (12¾ × 19 in.) Private collection

buildings of Amberley and the landscape of the Sussex Downs. Both works demonstrate the adaptation of the Pre-Raphaelite style of landscape painting to topographical purposes.

The Pre-Raphaelite objectives of truthful observation and accurate delineation were thus adopted by artists and antiquarians to document the ancient architecture of Europe. Many were seized by the fear, justified by contemporary and subsequent events, that much of it would be mutilated by restoration or destroyed.

A campaign of architectural record-making was led by Ruskin. As a young man he had admired and learnt from the architectural drawings of Samuel Prout; his early drawings contain the emphasis on details of decrepitude which the topographical tradition dictated. However, during the 1850s Ruskin evolved a style of draughtsmanship in which all pictorial emphasis is directed towards the materials and forms of the buildings, and no distraction allowed. Ruskin recognized the value of photographs for recording the appearances of buildings; and his own draughtsmanship was analogous to the process of photography in its relentless search for information. He described his drawings as 'written notes of certain *facts*, . . . put down in the rudest and clearest way, as many as possible.'

Ruskin was obsessed with the architectural history of Venice, which he described in *The Stones of Venice* (1851–3). He visited the city nine times between 1841 and 1888, and found inspiration there for some of his most beautiful drawings, including *The South Side of the Basilica of St Mark's, Venice, seen from the Loggia of the Doge's Palace* (Plate 45). This watercolour was made as an illustration for a book of plates entitled *Examples of the Architecture of Venice* and reflects both Ruskin's profound knowledge of, and sheer delight in, the ancient building. *The South Side of the Basilica of St Mark's* takes the Pre-Raphaelite method of close proximity to the subject to its logical conclusion. Ruskin has crammed his view of the double tiers of marble columns and Byzantine capitals into an upright rectangular sheet which he extended twice so that more of the building could be shown. No view is given of the familiar silhouette of the basilica or of neighbouring buildings; he has concentrated the composition entirely on the detail and essence of this single structure. All formality has been dispensed with; the decoration and texture of certain surfaces are rendered with minute exactitude while other areas are left almost blank. Passionate and committed though this work may be Ruskin's urgent desire to investigate and record caused him to economize his efforts rather than work up more finished or pictorial compositions.

In 1854 Ruskin wrote to G.P. Boyce recommending that he study the projecting flank of the façade of St Mark's from the loggia of the Doge's Palace, which was 'one point, as far as I know, never drawn . . . if you make friends with the old porter of the Ducal palace – and get into the upper loggia at the corner St. Marks portico comes in somehow so – [accompanied by a sketch] with the top of the broken square capital of the St. Jean d'Acre pillar underneath – & St. Marks place behind most beautifully.'

Boyce's journey to Italy in 1854 was an act of homage to Ruskin; he studied the buildings that Ruskin considered important and at risk, and in doing so he set a pattern for a succession of architectural watercolourists whom Ruskin advised, or commissioned, to paint specific buildings. Ruskin was concerned that Boyce might not 'estimate justly the value of *Verona*' as a source of subjects: 'the little group of the Scala Monuments', he wrote, 'is altogether unrivalled *in the world* for sweet colour & light and shade; and in these times there is no knowing how long it may stand.' Boyce's *Tomb of Mastino II della Scala* (Plate 44) is one of two drawings that he made of Verona and it fulfills the criteria that Ruskin and he agreed upon: '*near* subject – good architecture – colour – & light & shade.'

After the death of his father in 1864 Ruskin gained complete financial independence; this allowed him to commission artists to record the appearances of threatened buildings throughout Europe. In 1878 he founded the Guild of St George, which he hoped would be the embryo of a socialistic community in which all would work for the general good and where emphasis would be placed on the spiritual importance of art. The museum of the Guild

became a repository for the works of art which Ruskin had accumulated, and a spur for him to add to the collection.

The most important artist to work for Ruskin and the Guild of St George in Venice was John Wharlton Bunney. Ruskin and Bunney had travelled together to Venice in 1869 and Bunney settled in the city for the remaining years of his life. *Palazzo Manzoni, on the Grand Canal, Venice* (Plate 46) was one of the first watercolours that he made for Ruskin. In its exact depiction of the decoration of the palace and the colours and grain of its marble cladding it is a *tour de force* of architectural watercolour painting. Bunney allowed no expression in the handling of paint; record making was his only objective. The view of the palace is squeezed into the overall composition without the indulgence of subsidiary areas or picturesque details. This was a joyless and painstaking use of the medium (the watercolour was 'retouched and invigorated by J. Ruskin' at some stage), but Bunney achieved his purpose, which was to convey by means of Pre-Raphaelite realism the architectural form of the building.

Ruskin bought a number of watercolours for the Guild of St George from the American artist Henry Roderick Newman, whom he first met in 1879. He considered the close-up studies that Newman made of individual buildings in Florence as 'quite the most valuable records yet existing of the old city'. In the St George's museum catalogue they were described as being 'copied with such precision and exactitude as if every block, and every subject, was to be taken singly as a separate archæological study'. This might serve as a definition of the Ruskinian objective in architectural painting.

Newman had assimilated and understood Ruskin's artistic theories as a young man. He said of his early career: 'My earliest work was careful studies of the old buildings of New York City with their tiled roofs, . . . Every one of these houses is now gone, but they helped me to understand European architecture. My first introduction to that was at Chartres. From [t]here I went to Italy.' Newman's architectural views in Florence, elsewhere in Tuscany, and Venice, date from 1870 onwards; his *View of Florence, from the Gardens of the Palazzo de' Mozzi* (Plate 47) includes the Duomo and Palazzo Vecchio. The composition is framed in the foreground by olive trees and a fig sapling, and is more conventional than his earlier work in its picturesque view-finding.

Some watercolourists of the 1860s sought to describe the transformation that parts of the landscape of Britain had undergone during the Industrial Revolution. Wherever the commercial impetus of Victorian England held sway, railway lines and bridges were constructed; harbours and piers built and rivers embanked; and factories and warehouses appeared in the landscape.

Henry George Hine painted his *Railway Line at Camden Town* (Plate 49) at about the same time as Ford Madox Brown's view of Hampstead (see Plate 29) and at only a few miles distance. Hine, however, introduced an element unimaginable to earlier generations: the arched railway embankments which provide access to the main termini of King's Cross, Euston and St Pancras stations. Georgian houses are seen facing the massive brick structure, which carries a locomotive hauling open carriages into London at roof-top level.

Alfred William Hunt was encouraged to look for subjects in the industrial landscape of the north-east of England, where he had friends and patrons. Hunt was fascinated by the weird shapes and improbable perspectives to be observed in the engineering and construction works which he found in progress. *Travelling Cranes, Diving Bell, & etc., on the Unfinished Part of Tynemouth Pier* (Plate 50) shows a view of the ruins of Tynemouth Priory and the lighthouse at the mouth of the River Tyne through a massive structure of wooden beams. He described in a letter of 1869 the purpose of the 'wooden staging – on the beams of which are laid tramways – and upon these tramways run travelling cranes with stones and diving bells – the stones to be let down each in its place to form the breakwater, . . . this being a solid mass causes the white cloud of spray where the waves break over it.' Hunt found a sublime beauty in a landscape in the process of industrial transformation; his watercolour gives a documentary account of a feat of engineering and captivates the eye with its abstract vortex of shapes and colour.

44. George Price Boyce, RWS (1826–1897). *Tomb of Mastino II della Scala*, 1854. 40 × 27 cm. (15¾ × 10⅝ in.) Collection of Christopher Newall

45. John Ruskin, HRWS (1819–1900). *The South Side of the Basilica of St Mark's, Venice, seen from the Loggia of the Doge's Palace.* Watercolour and pencil, heightened with white bodycolour, 95.9 × 45.4 cm. (37¾ × 17⅞ in.) Private collection

46. John Wharlton Bunney (1828–1882) (and John Ruskin). *Palazzo Manzoni, on the Grand Canal, Venice*, 1871. Watercolour and bodycolour, 69.8 × 83.8 cm. (27½ × 33 in.) Sheffield, The Ruskin Gallery – Collection of the Guild of St George.

47. Henry Roderick Newman (1843–1917). *View of Florence, from the Gardens of the Palazzo de' Mozzi*, 1877. Watercolour and bodycolour, 24 × 33 cm (9½ × 13 in.) New York, Hirschl & Adler, Inc.

48. John Brett, ARA (1830–1902). *View at Great Yarmouth*, 1868. Watercolour, 31.8 × 47 cm. (12½ × 18½ in.) Private collection

49. Henry George Hine, RI (1811–1895). *Railway Line at Camden Town*. Watercolour and bodycolour, 17 × 24.6 cm. (6¾ × 9⅝ in.) London, Anthony Reed Gallery

John Brett, another painter in the Pre-Raphaelite circle, used the medium to record the townscapes of the British Isles. His *View at Great Yarmouth* (Plate 48) shows a timeless scene of a fishing boat setting sail within the harbour at Yarmouth. The background consists of a miscellaneous but eminently naturalistic assortment of boats, a derrick for lifting loads of fish from the holds, and warehouses in which the catches would be sorted and sold, each complete with a wooden-built watch-tower from which the fleet might be observed.

A close-up view of a fisherman, *A Fisherman with his Dinghy at Lulworth Cove* (Plate 51), was painted by William Henry Millais, the brother of John Everett Millais. During the 1850s and 1860s he studied the coasts and river landscapes of the British Isles, and occasionally represented scenes of working life. W.H. Millais subscribed to Pre-Raphaelite principles in his conscientious description of geological features. In *A Fisherman* he has observed both the pebbles of the beach and the dramatic strata of rock which form the headland at Lulworth.

Pre-Raphaelite principles remained current in British art for several decades. Ruskin had perversely objected to a watercolour of Snowdon by the Manchester artist Henry Clarence Whaite, when it was exhibited at the Royal Academy in 1859, as 'suffering under the . . . oppression of plethoric labour'. Whaite exhibited *Castle Rock, Cumberland* (Plate 52) in 1877; in this instance the artist has sought a solution to the problem, which all watercolourists faced eventually, of how to escape the dictates of obsessive realism and the commensurate labour of meticulous handling. *Castle Rock* is painted on a large scale and the elements of the landscape, which include the sheer rock face and the upland distances as well as the foreground meadows, woodland and farmstead, are vibrant textures of repeated strokes of colour.

John William Inchbold had experienced Ruskin's immediate supervision in the early years of his career as a landscape painter. He was described by William Michael Rossetti as 'perhaps highest of the strictly Pre-Raphaelite landscape painters . . . Much praised by Ruskin'. Inchbold was a rootless and peripatetic individual who painted landscapes in many different parts of Europe in the course of his lifetime. His fondness for the Alps, which he first visited in 1856, may have been inspired by Ruskin's own enthusiasm, and he returned to paint in Switzerland on a number of occasions. His *View above Montreux* (Plate 53) demonstrates his continuing adherence to Pre-Raphaelite principles in a general sense; however, the handling of the paint is deceptively loose. In the foreground, for example, areas of green are applied in broad patches, and in the distant mountainside effects of atmospheric mistiness are achieved by thin washes of colour. While an appearance of detail is given, the overall impact was more important to the artist. In 1874 the following account appeared:

> Mr. Inchbold interprets his subjects with great taste and feeling, idealizing always to some extent, so that his drawings tend rather to a spiritual and not quite substantial conception of things, than to a material solidity; but in times of a vulgar yet powerful realism, this refinement is like poetry after prose. (Quoted from *Portfolio* by A. Staley: *The Pre-Raphaelite Landscape*, 1973)

Inchbold's watercolour represents a meeting-point between the technical virtuosity of Pre-Raphaelitism and the pictorial restraint and sensitivity of the Aesthetic Movement.

For some watercolourists minute detail and realism of colour became habitual ends. Anna Alma-Tadema, the daughter of Lawrence Alma-Tadema, was born after the main force of Pre-Raphaelitism was spent. She gave an extraordinary demonstration of photographic realism and brilliant colour in her *Eton College Chapel* (Plate 54). Painted in 1885, it would be hard to say whether this was the product of an ongoing tradition of Pre-Raphaelite architectural view-painting, or the revival of interest in minute observation which occurred in the closing years of the century. Kate Greenaway was encouraged by Ruskin to study nature in the form of sections of turf and lichenous rock. The specimens were taken from Ruskin's garden at Brantwood in the Lake District and sent to her in her studio in Hampstead, 'Not to tease you – but they'll go on growing and being pleasant companions.'

50. Alfred William Hunt, RWS (1830–1896). *Travelling Cranes, Diving Bell, & etc., on the Unfinished Part of Tynemouth Pier,* exhibited 1867. Watercolour, with scratching out, 32.4 × 27 cm. (12¾ × 10⅝ in.) Collection of Christopher Newall

51. William Henry Millais (1828–1899). *A Fisherman with his Dinghy at Lulworth Cove.* Watercolour and bodycolour, heightened with gum arabic, 16.2 × 26.3 cm. (6⅜ × 10⅜ in.) Cambridge, Fitzwilliam Museum

52. Henry Clarence Whaite, RWS (1828–1912). *Castle Rock, Cumberland*, 1877. Watercolour, 76.2 × 133.3 cm. (30 × 52½ in.)
Liverpool, Walker Art Gallery

53. John William Inchbold (1830–1888). *View above Montreux*, 1880. Watercolour, 30.8 × 50.3 cm. (12⅛ × 19¾ in.)
London, Victoria and Albert Museum

54. Anna Alma-Tadema (before 1869–1943). *Eton College Chapel*, 1885. Watercolour and bodycolour,
52 × 36 cm. (20½ × 14⅛ in.) Private collection

Greenaway's *Study of Rock, Moss and Ivy* (Plate 55) was made in response to Ruskin's gifts and presented to him as an example of dutiful observation. It represents possibly the very last of many watercolours specifically done to satisfy Ruskin's theoretical view of landscape and nature painting.

The Pre-Raphaelite perception of landscape and architecture resulted from a desire to penetrate and understand the inner significance of a place or a building, and to describe with selfless and dispassionate objectivity its features and characteristics. Pre-Raphaelite watercolourists drew ever closer to their subjects in the search for both information and abstraction; on the one hand they hoped to explain the contents of the subject and on the other to make pictorial form from the shapes and textures of which the physical world consists.

55. Kate Greenaway, RWS, RI (1846–1901). *Study of Rock, Moss and Ivy*, 1885. Watercolour and bodycolour, 18.7 × 33 cm. (7³⁄₈ × 13 in.) Sheffield, The Ruskin Gallery – Collection of the Guild of St George

Throughout the nineteenth century painters had been commissioned to make illustrations. Turner made preparatory drawings for etchings and lithographs, and amongst the Pre-Raphaelites Millais and Frederick Sandys produced important illustrative work. As has been said earlier, the livelihood and prosperity of many artists depended on the trade. However, it was only during the later 1860s and 1870s, when in fact there was a downturn in business amongst the publishers of printed illustrations, that illustrators turned in large numbers to the medium of watercolour, and had a stylistic impact on how the medium was used.

The formative experience of designing illustrative plates for books or magazines had a direct bearing on the aesthetic preconceptions of a younger generation of artists. The images that they drew, and which were transferred into black and white wood-block engravings, were composed in direct and legible forms which generally filled the overall picture space. To some extent these considerations influenced the watercolour subjects of the illustrators, which in any case were often worked-up versions of subjects originally treated as black and white illustrations. A painted view was no longer supposed to correspond minutely to the subject under scrutiny, and realism was not accepted as an absolute standard.

Various informal groups of watercolourists who had previously worked, or continued to work, as illustrators, were formed. The most conspicuous of these centred around the personality of Frederick Walker during the second half of the 1860s, and was later known as the Idyllists. The names of John William North and George John Pinwell are associated with the group. The term 'Idyllists', however, was only attached to them in the 1890s.

The Idyllists painted figurative subjects in domestic or landscape settings. Walker and North favoured the thematic treatment of scenes from contemporary life. Pinwell retained the practice of giving imaginative form to historical or literary texts. None of the Idyllists painted pure landscapes; North's landscapes without figures, such as *The Old Pear Tree* (see Plate 90), derive from his later years after Walker and Pinwell had died. They all occasionally painted in oil, but their most intimate and characterful works were watercolours, and these represent the last great achievement of the Victorian tradition of bodycolour technique.

The Idyllists were concerned with the union of figures with their immediate surroundings, rather than with the material analysis of the physical world attempted by the Pre-Raphaelites. The view that was offered of landscape remained restricted; human activities were observed within a confined foreground and at close range. Walker's *Spring* (Plate 56) shows a young girl, intent on her purpose of picking primroses, pushing aside the whip-like willow stems which conceal clusters of flowers. One senses in the watercolour the first glimmer of warmth of an English spring, and notices that the model is carrying rather than wearing her coat. The points of green about to burst on the branches, and the fresh grass on the ground of the coppice, identify precisely the time of year.

In *An Amateur* (Plate 57) Walker has shown a coachman opening a clasp-knife with the intention of cutting a cabbage. Circumstantial evidence of the outside world is provided by the lodge and gates (behind which a vehicle is parked) of a country house, in which one presumes the man's employer lives. However, the essential object of the watercolour was to observe secretly a private moment in the life of a working man. The pride that he takes in the vegetables that he has grown, and his hesitation in deciding which cabbage to pick, are subtly evoked. Walker has viewed the scene with sensitivity and discretion; he has allowed a view into a confined place without disrupting the preoccupation of his unconscious model.

Both *Spring* and *An Amateur* depend for their naturalism on Walker's ability to convey colour and depth of tone in what Ruskin called his 'semi-miniature, quarter fresco, quarter wash manner'. His use of bodycolour was criticized by a reviewer in the *Art Journal* of 1869, who wrote:

> It will be worth anyone's while to observe the artist's mode of manipulation, – the pigments are laid on thick, as in the *impasto* of *tempera*; the method has more singularity than merit; the painter is wholly defiant of opacity; when he paints a wall, he lays on mortar as liberally as a mason, and thus the wall is a wall accordingly; it stands firm, has solid substance, and throws off light, just as any other masonry.

Walker drew a caricature of himself squeezing paint out of a vast tube of Chinese White and asked: 'What *would* "The Society" say if it could only see me?' J.W. North's account of Walker's technique explains how he and the other Idyllists gained such an immediate feeling of the landscape:

> Walker painted direct from nature, not from sketches. His ideal appeared to be to have suggestiveness in his work; not by leaving out, but by painting in, detail, and then partly erasing it. This was especially noticeable in his water colour landscape work, which frequently passed through a stage of extreme elaboration of drawing, to be afterwards carefully worn away, so that a suggestiveness and softness resulted – not emptiness, but veiled detail. His knowledge of nature was sufficient to disgust him with the ordinary conventions which do duty for grass, leaves, and boughs; and there is scarcely an inch of his work that has not been at one time a careful, loving study of fact. (J.G. Marks: *Life and Letters of Frederick Walker*, 1896)

'Composition is the art of preserving the accidental look', wrote Walker, thus acknowledging his impulse to transcend Pre-Raphaelite observation. The creative process which he undertook derived first from a minute inspection of the physical world, but also depended on the selection and arrangement of elements into harmonious and significant pictorial forms.

Walker revered William Henry Hunt and owed his own bodycolour technique to a study of Hunt's still-lifes and interiors; in turn Walker was acclaimed by contemporary and younger artists. He invented a type of rustic subject which was imitated by later watercolourists until the turn of the twentieth century.

Although Walker and his friend North were both born and brought up in London, they made long stays in the countryside to seek out rural subjects. North rented an ancient manor house in Somerset, called Halsway Court and this beautiful building and the surrounding fields and villages appear in many of the Idyllists' watercolours of the later 1860s. Walker was a frequent visitor from 1868; on one occasion he wrote: 'I came here, as I thought, on a "flying visit," but the place is so completely lovely, and there's so much paintable material, that I expect to remain until quite the end of the month.'

In *Halsway Court* (Plate 58) North has shown the stone-built house and the garden glowing with colours made brilliant by the effects of evening light. In the foreground is a bowling green where a child sits while a young couple talk and gaze at one another across the garden wall. The dense and asymmetrical composition is characteristic of an artist whose formative training was as an illustrator. (Both North and Walker had worked for

56. Frederick Walker, ARA, RWS (1840–1875). *Spring*, 1864. Watercolour and bodycolour, 62.2 × 50.2 cm. (24½ × 19¾ in.)
London, Victoria and Albert Museum

57. Frederick Walker, ARA, RWS (1840–1875). *An Amateur* (otherwise known as *Coachman and Cabbages*), exhibited 1870–1. Watercolour and bodycolour, 17.7 × 25.3 cm. (7 × 10 in.) London, British Museum

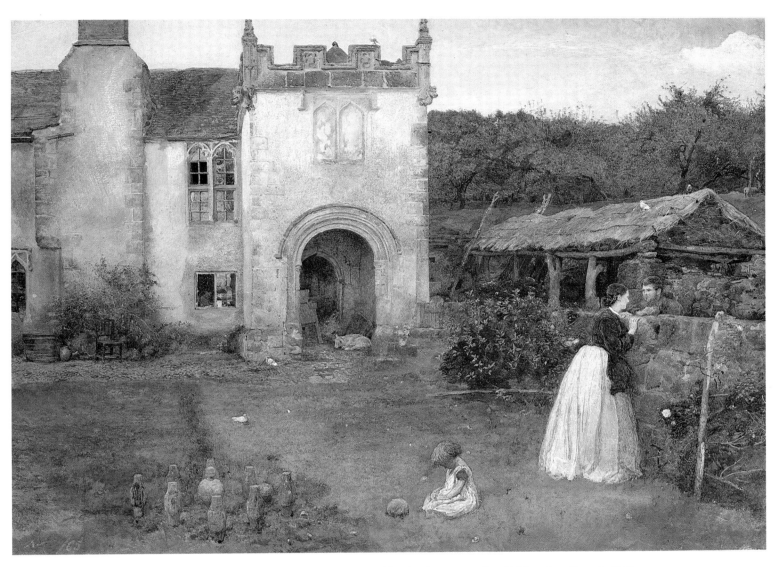

58. John William North, ARA, RWS (1842–1924). *Halsway Court* (possibly also known as *The Old Bowling Green*), 1865.
Watercolour and bodycolour, 33 × 44.5 cm. (13 × 17½ in.) Collection of Robin de Beaumont

the Dalziel Brothers in London.) The view of Halsway Court illustrated here represents an extreme elaboration of naturalistic bodycolour painting and was probably the same painting that North exhibited in 1867 at the Dudley Gallery under the title *The Old Bowling Green*. On that occasion the *Art Journal* 'observed that opaque is here used in unmitigated manner'; indeed the range and depth of colour, and realism of detail, depended upon the use of bodycolour. Walker wrote of his friend as they worked together in Somerset: 'North here is doing capital work (water colour), he is most sincere over it, each inch wrought with gem-like care.'

George John Pinwell's technical proficiency as a watercolourist owed something to both Walker, with whom he was a contemporary at Leigh's School, and North. In *In a Garden at Cookham* (Plate 59) Pinwell demonstrated what his biographer George C. Williamson described as 'his love of tiny brilliant touches of crude vivid colour, which he used with such dexterity and which gave jewel-like effect to the surface of the picture, and lit it up in a marvellous way.' The structure of the composition is based on a careful distribution of horizontal and vertical elements, the dense pattern of which extends throughout the pictorial space and provides a matrix into which the figures have been positioned. This quality, seen previously in North's *Halsway Court*, derived from the illustrator's instinct to extend structural patterns over the entire surface of a composition.

Pinwell was admired for his romantic imagination and for the strange and beautiful renditions of historical and literary subjects that he painted.

> If ever there was a dreamer of dreams 'born out of his due time,' it was George Pinwell, and his art is one of the most peculiar which has marked modern days. This is indeed a very strange, half-real, half-poetical world with which he is concerned, and many of his compositions are analogous, in the impression they give to the spectator, to one of those old North-country ballads which commencing quietly with a maiden seated at her spinning-wheel, or a page riding across the heather, end in shame and death. (Harry Quilter: *A Catalogue of Pictures and Sketches by George Mason and George Pinwell*, Birmingham, 1895)

Pinwell's epic watercolour *Gilbert à Becket's Troth* (Plate 60) takes for its subject the history of the Saracen maiden who fell in love with the captive crusader Gilbert à Becket. After she had helped him escape from the Holy Land, the forlorn yet determined maid followed him to England, where she met with hostility and indifference from the native population. When the picture was exhibited at the Old Water-Colour Society in 1872 the *Art Journal* was full of praise for it and concluded: 'It is a work of great self-possession to entertain such a subject, but it is a triumph to carry such a theme to an issue so felicitous.'

Amongst Victorian painters Pinwell may be compared with Leighton in his orchestration of the range of psychological reactions within a large-scale figurative composition. *Gilbert à Becket's Troth* is a gothic presentiment of Leighton's *Captive Andromache* in its representation of an isolated and alien central figure surrounded by peripheral strangers.

Walker and Pinwell were not close friends, but their works were often compared. Quilter wrote that Pinwell was:

> As pre-Raphaelite in execution as Walker himself, and indeed almost more so, he is also what Walker never was, pre-Raphaelite in feeling, and has the faint, half-sick straining after beauty which marks the school. Pinwell was always thinking about beauty, and Walker was always getting it – therein lies much of the difference.

George Williamson noted that 'Walker did not express any great satisfaction with Pinwell's pictures. They did not appeal to him in their hidden poetry, as he preferred a motive more clear and apparent, and colour more refined.'

In Fred Walker's great watercolour *A Fishmonger's Shop* (Plate 61) a young woman, who wears a dress of

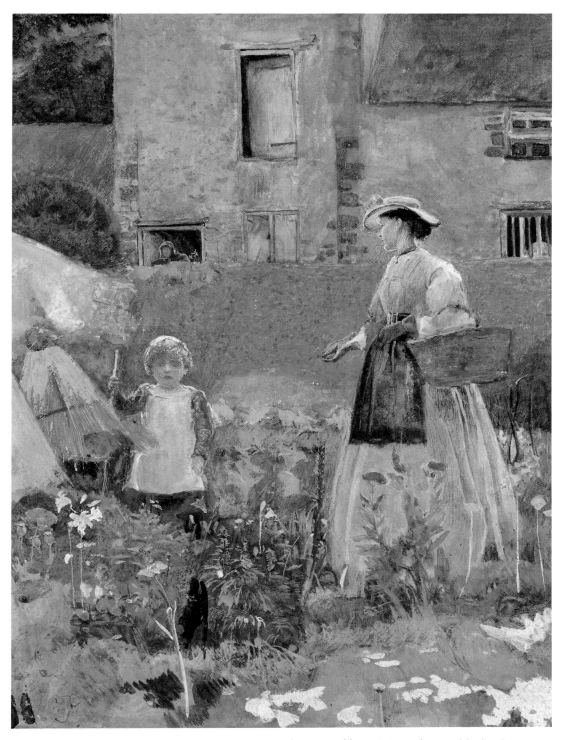

59. George John Pinwell, RWS (1842–1875). *In a Garden at Cookham*. Watercolour and bodycolour, 19 × 14.3 cm. (7½ × 5⅝ in.) Collection of Mr and Mrs Michael Bryan

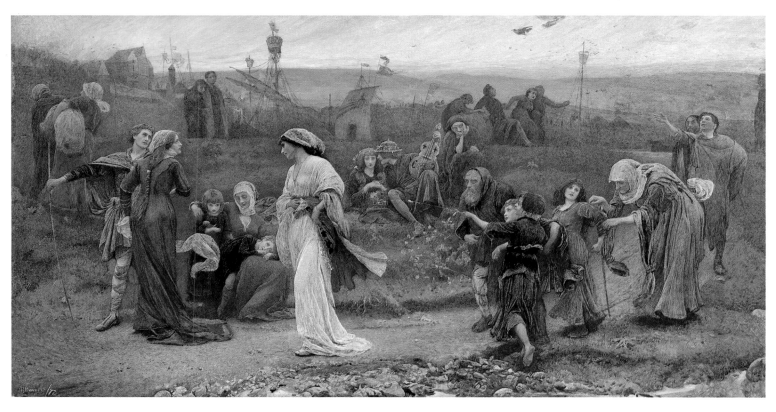

60. George John Pinwell, RWS (1842–1875). *Gilbert à Becket's Troth* (otherwise known as *The Saracen Maid*), 1872. Watercolour and bodycolour, 55.9 × 109.2 cm. (22 × 43 in.) Port Sunlight, Lady Lever Art Gallery

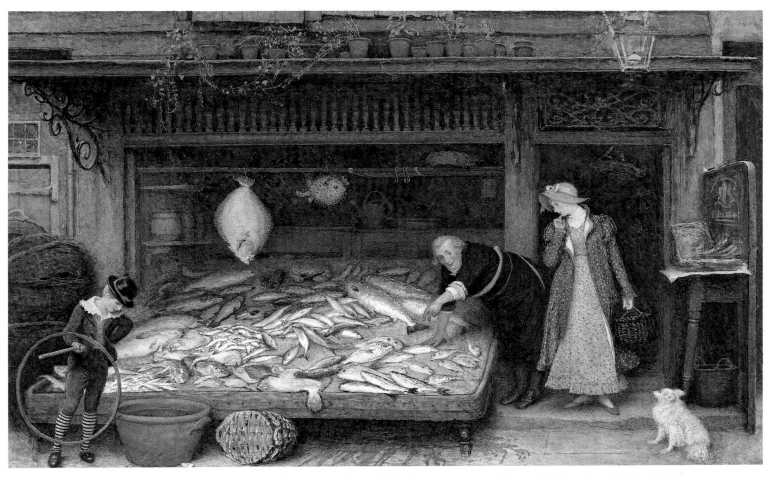

61. Frederick Walker, ARA, RWS (1840–1875). *A Fishmonger's Shop*, exhibited 1872–3. Watercolour and bodycolour, 35.6 × 57.2 cm. (14 × 22½ in.) Port Sunlight, Lady Lever Art Gallery

Regency period, deliberates over the display of fish outside a shop. As in *An Amateur* the essence of the action portrayed is momentary and easily understood; the subtlety and elegance of the subject lie in the description of a moment of uncertainty on the part of the woman. The abstract beauty of the watercolour is in the complex organization of elaborate detail and contrasting colours within, and completely filling, the rectangular format and narrow depth of field.

In October 1872 Walker had written to North: 'I'm working hard at a fishmonger's shop, with a great slab of fish, and a fair buyer!' A description has survived of Walker drawing his sister Mary as she posed outside various fish shops in the London streets; the artist's vantage-point was a four-wheeled carriage parked alongside.

A Fishmonger's Shop was rapturously received at the Old Water-Colour Society Winter Exhibition of 1872–3. The *Athenaeum* reviewer described the 'showboard . . . loaded with superbly painted fish of all kinds, of all degrees of lustre and colour, an aggregate of gems, . . . This is a little masterpiece of colour, both local and general.' The *Art Journal*'s obituarist in 1875 recalled the watercolour as 'a small drawing, but of exquisite manipulation, and absolutely glittering with beautiful tints . . . Mr. Ruskin objects to this drawing, but only because the labour spent on it "would have painted twenty instructive studies of fish of their real size." ' In painting *A Fishmonger's Shop* Walker did not seek, as Ruskin pretended to think he should, to catalogue the different types of fish, but rather to describe an incident of everyday life in which the relationship between the figures and their surroundings might be clearly understood. 'I have put into it all that I know,' he said. Burne-Jones expressed the opinion: 'I think for an absolute representation of what a scene in a story would be like F. Walker's drawings are perfection. Taking the event that he has got to illustrate as his object, he renders it exactly.'

The Idyllists represented a physical world which intrigues the spectator by its familiarity but which remains inaccessible. Knowledge of the materials of which that world consisted was no longer displayed for its own sake, and consequently realism was transformed into a shifting mirage where the appearance of things was suggested rather than stated. The watercolours of the Idyllists, whether narrative or thematic in their story-telling purpose, depend on the artists' empathy for their figures, who are caught unawares either in the course of their daily lives, or as the protagonists of historical or literary dramas.

If the Idyllists represented a real world adapted to the artists' imaginative purposes there were amongst their contemporaries in the 1860s and 1870s painters who created deceptively realistic images of total fantasy. Charles Dickens had written in 1853: 'In a utilitarian age, of all other times, it is a matter of grave importance that Fairy Tales should be respected.' He was taken at his word by those who painted scenes of fairy life. An age of materialism, and one which utilized the skills of painters to record the types and differences of all constituents of the physical world, extended this respect to subjects which existed only in fanciful imaginations.

Dicky Doyle's *Under the Dock Leaves – An Autumnal Evening's Dream* (Plate 62) goes beyond whimsy in its account of a fairy festival. A throng of tiny figures is seen arising like a whorl of evening mist from a woodland stream, and congregates to dance beneath the spreading leaves of the forest floor.

Dicky's brother Charles Altamont Doyle described the spirits that he painted in the night sky above St Giles' Cathedral in Edinburgh as 'personified memories recalled by the Bells as they ring a merry Midnight'. His phantasmagoric watercolour *Saint Giles – His Bells* (Plate 64) shows a stream of ghosts haunting the city, and includes heroes and villains, celebrities and members of the mob: Montrose is being driven to his execution; Prince Charles is escorted by the Clans; George IV enters the city in a carriage. With these figures are representatives of the Auld Town Guard, Fishwives of the city, and the 4th Light Infantry, seen departing for the Crimean War in 1854. Few watercolours reveal with such surreal clarity the painter's disturbed or joyful visions of the spirit world.

Eleanor Vere Boyle painted a series of small and minutely detailed watercolours from which engraved illustrations were made for Sarah Austin's *The Story without an End*. The strange and beautiful painting which

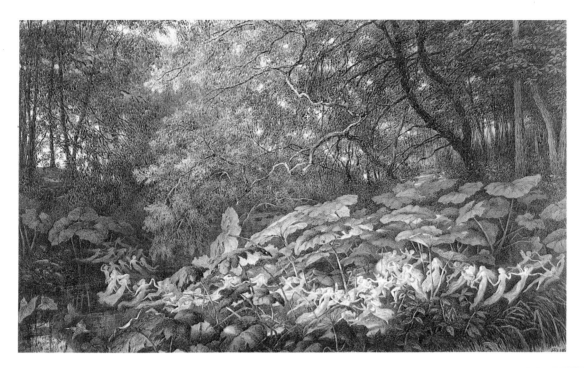

62. Richard Doyle (1824–1883).
Under the Dock Leaves – An
Autumnal Evening's Dream, 1878.
Watercolour and bodycolour,
50 × 77.5 cm. (19⅝ × 30½ in.)
London, British Museum

63. The Hon. Eleanor Vere Boyle
(1825–1916). *'And a neglected*
Looking-Glass/And the Child cared
nothing about the Looking-Glass',
c. 1868. Watercolour and
bodycolour, heightened with gum
arabic, 15.2 × 11.4 cm.
(6 × 4½ in.) Private collection

illustrates the lines 'And a neglected Looking-Glass/ And the Child cared nothing about the Looking-Glass' (Plate 63) offers a view of a broken glass amongst a curious assortment of dead leaves, clambering ivy and a peacock feather. Various microscopically observed insects crawl over the surface of the glass and the wings of a moth are seen camouflaged amongst the leaves. The reflection of a mouse is seen in the glass. Realism is taken to such a degree of intensity in this watercolour that it arrives at a level of a fantasy.

The minuteness and accuracy of mid-Victorian watercolour painting was ideally suited in its hallucinatory realism to the cult of fantasy subjects. At a time when painters became convinced that anything of material existence might be painted a converse belief grew up that anything that an artist could invent and depict might in fact exist.

Amongst the wider circle of watercolourists whose early careers had been spent as illustrators, or who continued occasionally to design for engravers, was Charles Green. The meticulous handling and technical skill shown in his watercolour 'Something Wrong Somewhere' (Plate 65) allows one to inspect the furnishings and paraphernalia of the back-room of a Victorian grocer's shop, where the proprietor and his wife puzzle over a ledger.

Helen Allingham worked as an illustrator for the *Graphic* and *Cornhill* magazines until her marriage in 1874 gave her sufficient financial independence to concentrate on watercolour painting. *Young Customers* (Plate 66) was worked up from a black and white illustration she had made for a book called *A Flat Iron for a Farthing*; she exhibited the watercolour at the Old Water-Colour Society in 1875, the year of her election to that association.

Watercolourists of the 1870s delighted in painting everyday scenes from contemporary life. In *Greeting the Postman* (Plate 67) Robert Walker Macbeth took a subject previously treated by Walker. Macbeth's version of the theme shows a family gathered at the door of a country house as the mother receives an eagerly awaited letter from a mounted postman. Hubert von Herkomer was another artist who was influenced by Walker towards subjects which describe the life of working-class people in country surroundings. Later he became friends with North, and learnt from him a rich and colourful bodycolour technique. Herkomer's watercolour *The Naughty Boy* (Plate 68), in which a disconsolate child is roughly held by his mother outside a cottage overgrown with roses and creeper, owes both its subject and technique to the Idyllists.

As the nineteenth century entered its last quarter an interest in the history and traditions of rural life grew up, and watercolourists sought to describe the appearance of the unspoilt countryside.

Edward Henry Fahey was not strictly an illustrator, but he composed his watercolours with the directness and fondness for abstract patterns which are associated with the Idyllists and their friends. His *Old Farm House* (Plate 70) is an essay in the textures of crumbling plaster. The expanse of wall is interrupted by stone-mullioned and wooden-framed windows, the irregular glazing of which reflects the light of the setting sun. The house is set four-square and at a range to allow only a part of its outline and a margin of roof to be seen. Its structural mass is conveyed by the shadowy view into the open door and the bright light which is seen from the far side of the house.

Helen Allingham was influenced by Walker and Birket Foster in her most characteristic subject, the vernacular architecture and country life of the southern counties; however, she surpassed both of them in the sympathy with which she described people and places. Allingham was deeply concerned for the condition of the rural population at a time when the consequences of agricultural depression were still being felt and when a traditional way of life was being disrupted by exodus from the land.

Her watercolour *South Country Cottage* (Plate 69) shows a country habitation unaffected by the despoliation of the countryside. The catalogue of Allingham's first exhibition in 1886 gave an account of how such cottages were being abandoned or demolished as unfit for modern living. Others were ruined, at least from an artistic point of view, by the improvements and rebuildings undertaken by commuters and week-enders.

64. Charles Altamont Doyle (1832–1893). *Saint Giles – His Bells.* Watercolour and ink drawing, 95.6 × 63.5 cm. (37⅝ × 25 in.) Edinburgh, St Giles' Cathedral

65. Charles Green, RI (1840–1898). *'Something Wrong Somewhere'*, 1868. Watercolour and bodycolour, 49.5 × 36.8 cm. (19½ × 14½ in.) London, Victoria and Albert Museum

66. Helen Allingham, RWS (1848–1926). *Young Customers*, exhibited 1875. Watercolour, 20.6 × 15.6 cm. (8⅛ × 6⅛ in.) London, The Leger Galleries

67. Robert Walker Macbeth, RA, RWS (1848–1910). *Greeting the Postman.* Watercolour and bodycolour, 14.6 × 20.7 cm. (5¾ × 8⅛ in.)
London, Victoria and Albert Museum

68. Sir Hubert von Herkomer, RA, RWS (1849–1914). *The Naughty Boy*, 1888. Watercolour and bodycolour, 17 × 24.6 cm. (6¾ × 9⅝ in.) Watford Borough Council Museum

69. Helen Allingham, RWS (1848–1926). *South Country Cottage*. Watercolour, 31.7 × 37 cm. (12½ × 14⅝ in.) Private collection

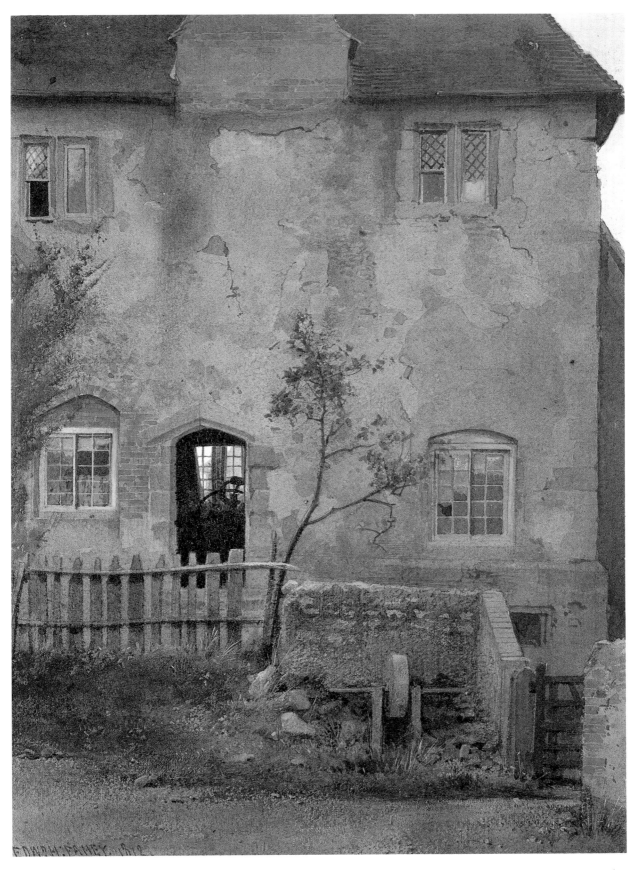

70. Edward Henry Fahey, RI (1844–1907). *Old Farm House*, 1872. Watercolour and bodycolour, heightened with gum arabic, 34.9 × 24.8 cm. (13¾ × 9¾ in.) London, Anthony Reed Gallery

From 1881 Helen Allingham lived in Surrey close to her most favoured painting haunts, and near her friend and mentor Birket Foster. Later she moved back to London and became, in a sense, a commuter in reverse. She and Kate Greenaway had houses in Hampstead and made painting expeditions into the Middlesex countryside together. Allingham has left a description of these trips:

> During the summer . . . we continued our outdoor work together, generally taking an early train from Finchley Road to Pinner, for the day. She [Greenaway] was always scrupulously thoughtful for the convenience and feelings of the owners of the farm or cottage we wished to paint, with the consequence that *we* were made welcome to sit in the garden or orchard where *others* were refused admittance. (M.H. Spielmann and G.S. Layard: *Kate Greenaway*, 1905)

Helen Allingham, following the example of the Idyllists, sought the informal and intimate character of a scene where the relationship between figures and their familiar surroundings might be observed. The accuracy with which she studied landscape and architecture allows her watercolours to stand as an historical record of the lost appearance and way of life of the English countryside.

Many watercolourists of the generation after the Pre-Raphaelites continued to record their surroundings and to paint watercolours which were small in scale and specific in observation. But their approach was more subjective. They were more deliberate in their selection, and sufficiently detached from the subject itself to delight in the abstract and asymmetrical shapes which might be seen in the physical world. In this sense they were advancing unconsciously towards a more modern aesthetic where the patterns and conjunctions of form were to become the principal concern of artists.

Ln the 1870s a mood of introspection and a feeling of cultural detachment entered the more progressive circles of British art. Painters retreated from a view of the physical world into a realm where they could explore their own fantasies and imaginations. Realism was no longer seen as the only means of relaying factual information about the material world, or as an aid to the story-telling function of a picture. If the imagery of watercolour painting remained literal it stemmed from the artist's power of invention rather than his capacity for observation; watercolourists sought to describe scenes which might strike chords of recognition in the spectator's subconscious mind, and to create images which were symbolical rather than narrative.

The Aesthetic Movement, like Pre-Raphaelitism before it, represented a rapid advance in ideas about the purpose and importance of art, and embraced all kinds of creative work. For the first time it was believed that the practice of art was an end in itself and that works of art should only be judged or justified according to the criterion of whether they were beautiful or not. Art was seen as spiritually uplifting and having the power of gratifying the eye, but its moral significance was not acknowledged. The age gave rise to the immortal slogan 'art for art's sake', and a generation of watercolourists adhered to the principle which the phrase encapsulates. However, just as the influence of the Pre-Raphaelites, adapted and sometimes misinterpreted, had gradually filtered into the works of a wider circle of watercolourists, so the principles of the Aesthetic Movement were only slowly understood by the community at large.

The roots of the Movement lay in the second and romantic phase of Pre-Raphaelitism. Burne-Jones's watercolours such as *Green Summer* (Plate 23) were amongst the very first in English imaginative art where the artist and spectator were not bound to a strict interpretation or narrative account of a pre-determined story. Conservative opinion, as has been seen, regarded this as a sinister direction. In 1869 the *Art Journal* had stated: 'This art has assuredly not the breath of life, the health of nature, or the simplicity of truth: it belongs to the realm of dreams, myths, nightmares, and other phantasms of diseased imagination.'

The following year, when discussing Burne-Jones's *Phyllis and Demophoön* (Plate 24) the *Art Journal* reviewer concluded that: 'Mr. Burne Jones in the Old Water-Colour Society stands alone: he has in this room no followers; in order to judge how degenerate this style may become in the hands of disciples, it is needful to take a walk to the Dudley Gallery.'

Even before Burne-Jones's resignation from the Old Water-Colour Society in 1870 the Dudley Gallery had provided exhibition space for aesthetically advanced watercolourists. Robert Bateman was the unofficial leader of a clique of Dudley artists who painted mythological subjects usually set in generalized arboreal landscapes. His watercolour *The Dead Knight* (Plate 71) is a curious product of Victorian medievalism. The body of a knight, partly covered by a shield decorated with armorial bearings, is seen lying beside a pool fed by a spring. A faithful hound

71. Robert Bateman (b. *c.* 1841–fl. 1889). *The Dead Knight*. Watercolour, 28 × 38.7 cm. (11 × 15¼ in.) Collection of Robin de Beaumont

72. Walter Crane, RWS (1845–1915). *Diana*, 1881. Watercolour and bodycolour, 35.2 × 24.8 cm. (13⅝ × 9¾ in.) Collection of Richard Dorment

sits beside its dead master in a woodland glade strewn with cow parsley. The spectator becomes the witness of the tragic and pathetic consequences of some chivalric mission or rivalry the circumstances of which are not revealed.

Walter Crane remembered how Burne-Jones's watercolours of the 1860s excited the circle of artists who exhibited at the Dudley:

> The curtain had been lifted, and we had had a glimpse into a magic world of romance and pictured poetry, peopled with ghosts of 'ladies dead and lovely knights,' – a twilight world of dark mysterious woodlands, haunted streams, meads of deep green starred with burning flowers, veiled in a dim and mystic light, and stained with low-toned crimson and gold, . . . (*An Artist's Reminiscences*, 1907)

Crane's later watercolours of slightly menacing wooded landscapes and vague but sinister mythical events represent a world which the artist has dreamt of rather than visited. In his *Diana* (Plate 72) the huntress seems to be leading her male followers through a primeval forest, perhaps to their destruction.

A third watercolourist in the Dudley circle was Alfred Sacheverell Coke, whose mythological subjects such as *Eros and Ganymede* (Plate 73) combine a delicate neo-classicism in their figurative and architectural elements with wooded landscape settings, perhaps inspired by the paintings of Uccello or Giorgione. Such watercolours explored the sexual connotations of classical literature and fable.

The watercolourists of the first stage of the Aesthetic Movement were seen as artistic dissidents and were generally ignored rather than condemned within the contemporary art world. However, in 1877 the opening of the Grosvenor Gallery made clear to the public at large that an artistic schism had taken place. On the one hand were the painters who were prepared to undertake profound and disturbing subjects and to confront stylistic and aesthetic issues, and on the other those who generally preferred bland and sentimental subjects which soothed rather than challenged the spectator's emotions.

Evelyn De Morgan exhibited at the Grosvenor Gallery from the year of its inception. Her mythological subjects maintained and adapted the tradition which Burne-Jones had re-invigorated. She took the subject of *Deianira* (Plate 74) from Greek myth, and expressed for those familiar with the fable the despair of a woman who realizes that she has been made the instrument of her husband's death, and for whom remorseful desolation was a prelude to suicide. The landscape of *Deianira* is a distillation of the impressions that the countryside of Italy had made on the artist's imagination; the draperies and gestures of the figure, which dominates the composition on an heroic scale, derive from her study of Michelangelo and the Italian Mannerists.

What had been at first a classicizing tendency in British art, discernible in the balance and passivity of various of Burne-Jones's watercolours of the 1860s, became during the later stages of the Aesthetic Movement a mood of unrestrained neo-classicism. In the paintings of Albert Moore all references to contemporary life were excluded in the interest of an imagery which had only the most abstract associations. Draperies and ornaments loosely evoke a classical past, but in a generalized fashion, and they are without historical foundation.

The title of Albert Moore's watercolour *Myrtle* (Plate 75) is taken from the spray of leaves and berries in a vase on the floor, but is otherwise without significance. Moore has represented a nude girl, seated with her legs concealed by flowing draperies, and with her arms raised and hands clasped behind her head. She is serenely indifferent to the artist's attentions and gives no indication of her feelings. *Myrtle* is a product of Moore's relentless search for beauty in the arrangement of shapes and colours, and of his exploration of the means of enlivening the folds of drapery by observing how they fall around the girl's body. The psychological calm and compositional equilibrium, and the absence of any moral or historical significance, make this a watercolour of sincere classicism and a fulfilment of the artistic ideals of the Aesthetic Movement.

In about 1871 Ruskin had written in a letter to Burne-Jones: 'Nothing puzzles me more than the delight

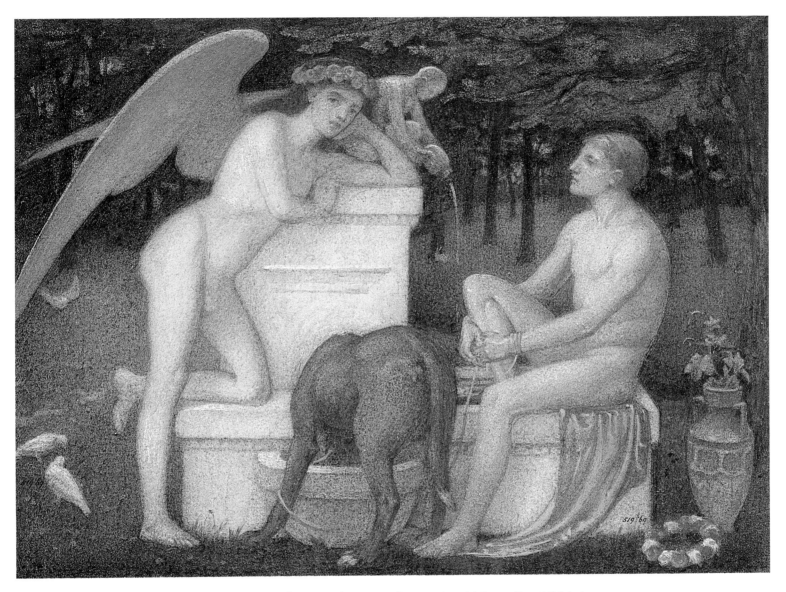

73. Alfred Sacheverell Coke (fl. 1869–1893). *Eros and Ganymede*. Watercolour, 20.3 × 26.7 cm. (8 × 10½ in.)
London, Victoria and Albert Museum

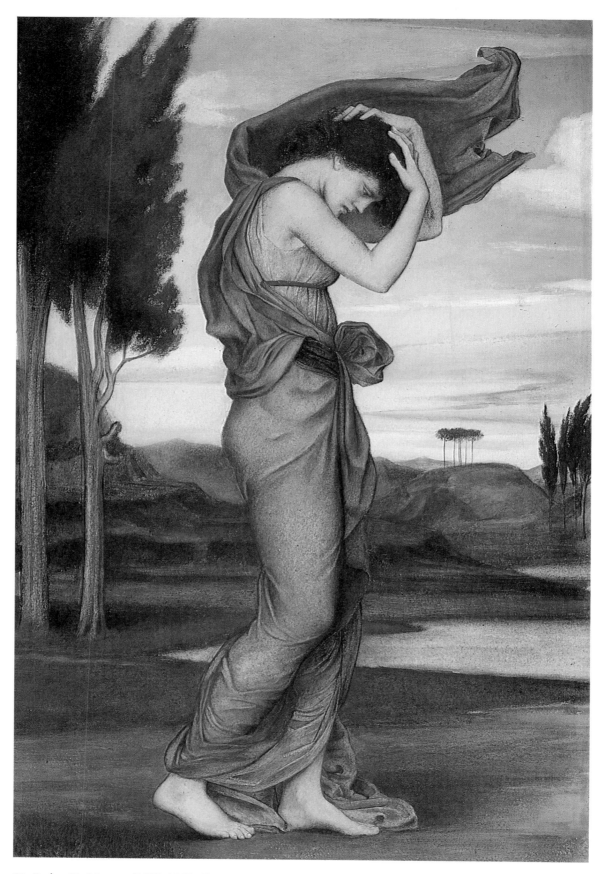

74. Evelyn De Morgan (1855–1919). *Deianira, c.* 1878. Watercolour and bodycolour, 45.7 × 30.5 cm. (18 × 12 in.) Private collection

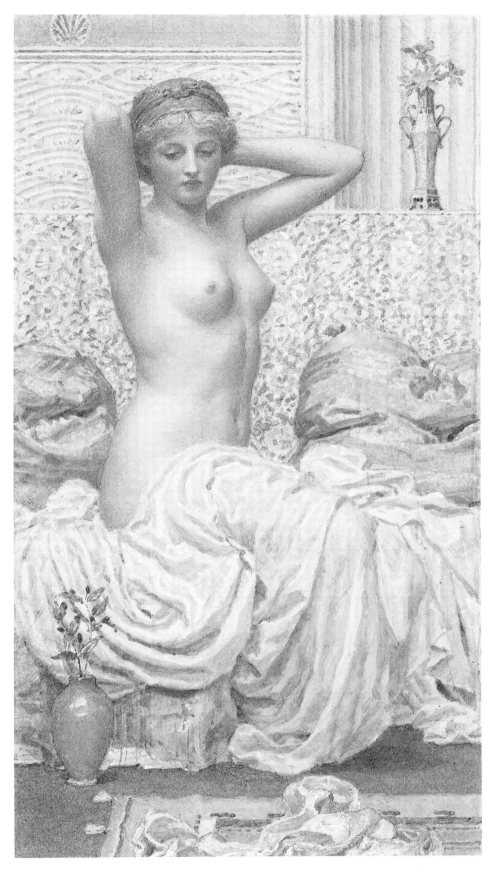

75. Albert Joseph Moore, ARWS (1841–1893). *Myrtle*, exhibited 1886. Watercolour,
28.8 × 16.5 cm. (11¾ × 6½ in.) Cambridge, Mass., The Fogg Art Museum

that painters have in drawing mere folds of drapery and their carelessness about the folds of water and clouds, or hills, or branches. Why should the tuckings in and out of muslin be eternally interesting?' During the Aesthetic Movement the study of draperies, and of draped and nude figures, preoccupied many watercolourists. It is clear, moreover, that draperies and figures were more than a concomitant of neo-classicism; they were components of subjects which were metaphors for repressed or passive sexual desire. For this reason mythological and classical subjects were favoured by a circle of artists and patrons who believed that art should address themes of implicit sexuality.

Lawrence Alma-Tadema, in his watercolour *Pandora* (Plate 76), departed from the reconstructions of Roman life for which he was famous, and created a simple and timeless portrait of a red-haired girl wearing a crown of bluebells and gazing at her curious casket, which is decorated with a sculpted sphinx. The watercolour expresses Pandora's hopes and fears of what she may reveal by opening the box, and is thus symbolic of a mood of anticipation.

Romantic medievalism remained a source of inspiration to painters throughout the Aesthetic Movement and up until the end of the century. Watercolourists based their subjects on literary or poetic texts, as Rossetti had done, or invented more generalized themes which evoked an image of the Middle Ages and supported the Victorians' view of themselves as the protagonists of a new age of chivalry. Watercolours of this type were only finally recognized as anachronistic when modernity was thrust upon painters by the First World War.

Byam Shaw exhibited his gigantic watercolour *The Queen of Spades* (Plate 77) at the Royal Academy in 1898. A.L. Baldry may have had the work in mind when, late in the same year, he wrote of the artist:

> As a colourist he is amazingly vigorous, rejoicing in brilliant combinations and gorgeous arrangements; in his composition he affects a wealth of detail which calls for the most judicious handling and exact consideration; and in choosing his subjects he inclines towards motives that are imbued with the spirit of mediaeval romanticism. ('Our Rising Artists: Mr. Byam Shaw', in the *Magazine of Art*, 1898)

The watercolour derived both from the artist's interest in the long tradition of iconic representations of the enthroned Madonna, and from the ritualized subjects and curious perspectives and symmetries of Rossetti's elaborate watercolours of the 1860s. As a means of artistic escapism it depended, as Baldry wrote, on the 'extraordinary fertility of his imagination to the power, of which he has consistently proved himself possessed, of embodying in his pictures a great variety of fanciful suggestion, and a succession of ideas fascinating to the people who affect that type of art which has a story to tell.'

Byam Shaw was the leader of a London-based group of watercolourists sometimes referred to as the 'label school' (so-called because of their frequent habit of signing their works within a *trompe l'oeil* cartouche). Eleanor Fortescue-Brickdale came under his influence and was the member of the group who most deliberately revived Pre-Raphaelite methods of observation and brightness of colour. *In the Spring Time* (Plate 78) is a meticulous and yet highly romantic watercolour in which a young girl wearing a flowing dress of silk or satin sits amongst bluebells.

Watercolourists associated with the Aesthetic Movement believed that the medium's potential for realism should be utilized to reveal the splendours of the imagination rather than mundane events from people's daily lives. They did, however, work as portraitists and in that genre provided a psychological insight into their own age. Watercolour was recognized in the 1870s as a medium which allowed a more intimate and personal approach to a sitter than oil, and which lent itself to the subtle and affectionate characterization of personality. The traditions of oil and watercolour portrait painting diverged during the nineteenth century; in professional terms there were few specialist portrait watercolourists, but many artists occasionally drew portraits in watercolour, either as the result

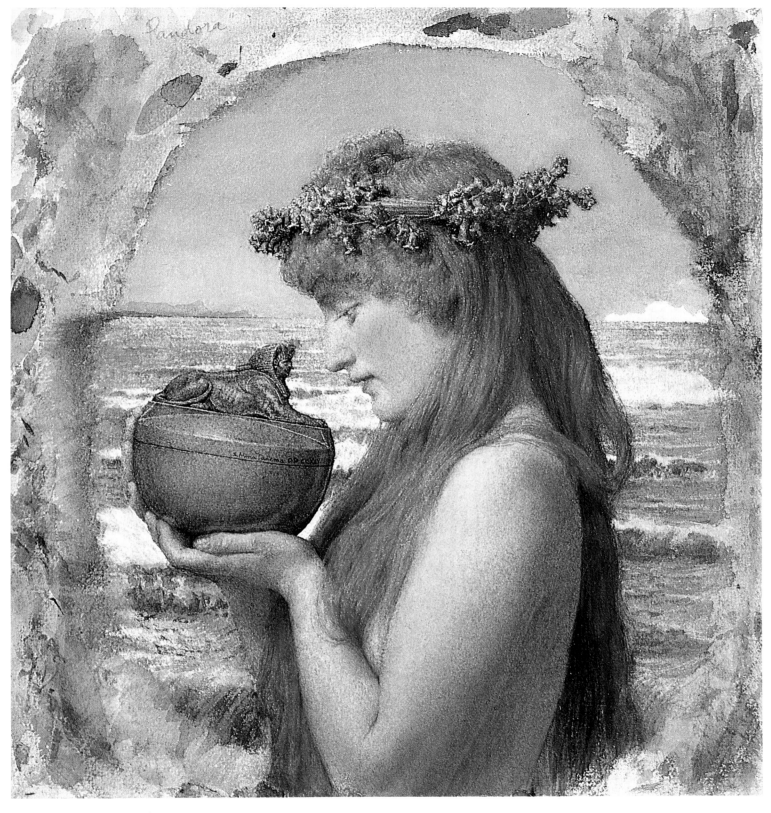

76. Sir Lawrence Alma-Tadema, OM, RA, RWS (1836–1912). *Pandora*. Watercolour and bodycolour, with scratching out, 26.3 × 24.4 cm. (10⅜ × 9⅝ in.) London, Bankside Gallery (Diploma Collection of the Royal Society of Painters in Water-Colours)

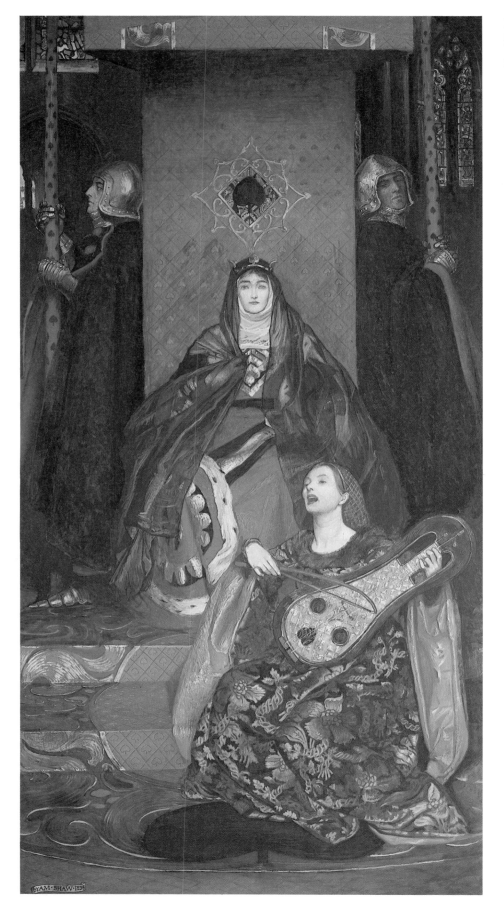

77. John Liston Byam Shaw, ARWS, RI
(1872–1919). *The Queen of Spades*, 1898.
Watercolour and bodycolour, 178 × 90 cm.
(70 × 36 in.) Private collection

78. Eleanor Fortescue-Brickdale, RWS (1872–1945).
In the Spring Time, 1901. Watercolour,
39.4 × 26.3 cm. (15½ × 10⅜ in.) Private collection

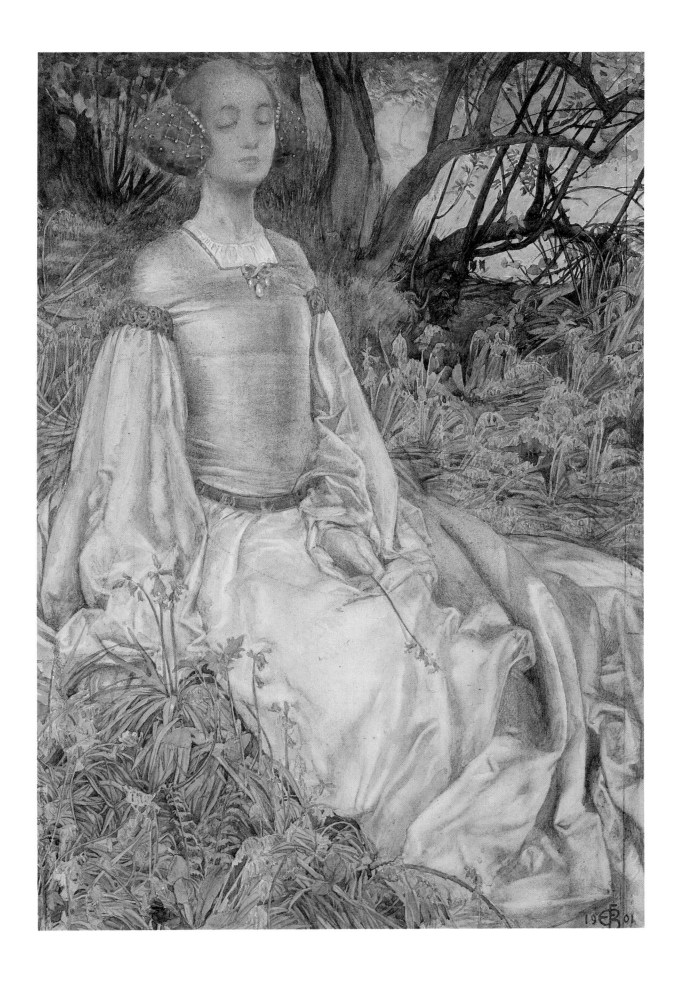

of commissions or as loving records of families and friends.

Edward John Poynter exhibited his *Portrait of Mrs J.P. Heseltine* (Plate 80) at the Dudley Gallery in 1873. The *Art Journal* observed: 'This is not a dress portrait, the lady being simply attired in a gown of an ancient pattern. The features are grave and thoughtful, the artist having followed the prevalent feeling which dispenses with a simper as an agreeable necessity to portraits.' The sincerity of the watercolour derives from Poynter's appreciation of the intelligence and sensitivity of the sitter, and the absence of grandiosity or pretension. The collection of works of art that Sarah and her husband J.P. Heseltine had assembled is alluded to only by the inclusion in the background of an ebonized stand on which are placed a Chinese bowl and leather bindings.

Walter Crane's portrait of his wife Mary, which he entitled *At Home: A Portrait* (Plate 2), was painted during their honeymoon in Rome in 1872, and exhibited at the Royal Academy in the same year. It conveys the pride and delight that Crane found in the person of his bride, who stands with a Japanese fan in one hand and a yellow-covered book in the other. Amongst the lovingly depicted ornaments which furnish the Cranes' rented rooms is a majolica vase inscribed 'Maria'. The arrangement of the room and its contents anticipated the aesthetic interiors which Crane was to be instrumental in popularizing in London, and the animal decorations of the tiled chimney-piece are similar to those which he later painted. The tapestry before which Mary Crane stands was of a kind which Crane particularly admired for its decorative quality. He gives fewer clues to personality in his portrait than Poynter had done, but entirely satisfies the precept of Aesthetic painting that all the elements of a picture should be beautifully arranged to combine into a harmonious composition.

Herkomer's portrait of John Ruskin (Plate 9) was published in the form of reproductive mezzotints and was thus available to a wide audience of Ruskin's admirers. Even though the portrait was criticized when first exhibited as lacking the sombre and grave character expected of the sage, both the artist and sitter understood its success to lie in its amiable and pensive quality; Ruskin was often drawn by friends and acolytes and was in addition a brilliant self-portraitist, but of this work he expressed particular satisfaction, saying on one occasion, '[it] is full of character, but is not like in the ordinary sense'. Soon after its completion, he wrote in a letter to a friend: 'I've been quite a prisoner to Mr. Herkomer, who has, however, made a beautiful drawing of me, the first that has ever given what good may be gleaned out of the clods of my face.'

In the area of portraiture watercolour allowed candid but affectionate accounts of individuals to be made. During the Aesthetic Movement the modesty and confidentiality of these portraits are reminders of the honesty and directness of the Victorian watercolourist's view of the world.

Kate Greenaway exhibited her watercolour *Misses* (Plate 79) at the Royal Academy in 1879. As a representation of contemporary middle-class childhood it depended both on observation, in the details of dress, and on exaggerated characterization, in the little girls' demeanour and expressions. Ruskin questioned Greenaway about how she created such a watercolour:

Do you only draw pretty children out of your head? In my parish school there are at least twenty prettier than any in your book [of illustrations] – but they are in costumes neither graceful nor comic – they are not like blue china – they are not like mushrooms – they are like – very ill-dressed Angels. Could you draw groups of these as they *are*? (M.H. Spielmann and G.S. Layard: *Kate Greenaway*, 1905)

Kate Greenaway's intention in painting *Misses* was not simply to observe the little girls who were her models, but to describe their inner personalities and self-conscious moods.

Landscape, like themes from contemporary life, did not generally appeal to the painters of the Aesthetic Movement. Pure landscape was, however, painted by the Etruscan group of painters, which was formed by a circle of English artists who worked in Italy. An Italian, Giovanni Costa, was the inspirational figure for this society.

79. Kate Greenaway, RWS, RI (1846–1901). *Misses*, exhibited 1879. Watercolour, 50.2 × 36.2 cm. (19¾ × 14¼ in.)
Liverpool, Walker Art Gallery

80. Sir Edward John Poynter, Bart., PRA, RWS (1836–1919). *Portrait of Mrs J. P. Heseltine*, 1872. Watercolour heightened with gum arabic, 40.5 × 30.5 cm. (16 × 12 in.) Private collection

81. Matthew Ridley Corbet, ARA (1850–1902). *Volterra, looking towards the Pisan Hills*, 1898–9. Watercolour, 50.2 × 69.2 cm. (19¾ × 27¼ in.) Collection of Christopher Newall

Although he maintained that watercolour lacked the expressive potential of oil and discouraged his followers from using it, various of the artists who revered him were occasional watercolourists.

The painters of the Etruscan circle, who exhibited together at the Dudley Gallery and the Royal Academy, and from 1877 at the Grosvenor Gallery, were formally associated as a group only in 1882–3. They believed that the purpose of landscape painting was to express the emotions and affections that are felt for a native or adopted land, and depended on the selection of the forms of nature rather than on the search for naturalistic truth. 'A picture should not be painted from nature', Costa pronounced. 'The study which contains the sentiment, the divine inspiration, should be done from nature. And from this study the picture should be painted at home, and, if necessary, supplementary studies be made elsewhere.'

George Howard, who became the 9th Earl of Carlisle in 1889, was a dedicated amateur painter and a committed member of the Etruscan group. He was seldom seen without a sketchbook, drawing-board, or easel in the course of his frequent peregrinations in Europe, or when at home in Cumberland or Yorkshire. In *The Fish-Pond at Vallombrosa* (Plate 1) he resorted to abstract pattern-making in his observation of the reflections of the trees and sunlit bank and the masonry of the pool-edge.

Another member of the Etruscan circle and a fellow exhibitor with Howard at the Grosvenor Gallery was Matthew Ridley Corbet. He made painting tours in Tuscany each year and was a close friend of Costa's. His *Volterra, looking towards the Pisan Hills* (Plate 81) fulfills the Etruscan principles of landscape painting in every respect except that of medium. Detail and foreground are subordinate to the geographical character and overall perspective of the landscape. What is in one sense a specific and accurate view of the Tuscan mountainside may also be understood as a symbolic representation of a quintessential type of landscape, calculated to remind the viewer of the sights and sensations of that country.

During the Aesthetic Movement watercolour painting came to express the inner moods and sensibilities of artists. Veils of subjective and highly personal meaning were drawn over the appearance of the real world and by this process the disguised and distorted forms assumed symbolic rather than naturalistic meaning.

For the greater part of the Victorian age watercolour painting had been seen as a separate field of activity to that of oil painting, but during the last two decades of the nineteenth century it was gradually integrated into the artistic life of the period. Watercolour was no longer the preserve of specialists; artists tended to work in all mediums, depending on their moods and pictorial objectives. Nor were watercolours discriminated against in the exhibition forums of the period. Professional allegiance assumed less importance. The debate about the status and usefulness of watercolour became less intense and prejudices against the medium were largely overcome.

After the technical development in the 1890s of methods of colour printing which allowed watercolours to be reproduced the separate traditions of watercolour painting and illustrative drawing merged. Many of the highly finished and brightly coloured watercolours of the late Victorian period were reproduced in illustrated books. The period was also marked by foreign influence and by consequent stylistic innovation. As soon as young painters began to enrol in Continental schools of art a new approach to the technique and composition of watercolours came about. George Clausen, for example, studied briefly at the Antwerp Academy and his watercolours reveal both the landscape of the Low Countries and the powerful influence of the Hague School, including the Maris Brothers and Anton Mauve.

In *Fisher Girls on the Beach* (Plate 82) Clausen has dispensed with the finish and detail sought by most of his contemporaries in England, and abandoned the conventions of perspective and spatial organization which had been customary in British watercolour painting. The figures of the untidy column of fisher girls form a stark triangle across the foreground of the composition, and are loosely and expressively sketched. Their bodies are chopped off at the edges of the composition in a way which suggests the arbitrary selection of a camera snapshot; the boats at sea, which are restricted to the extreme upper edge of the picture space, are expressed as a blur of brown sails half-obscured by poor visibility. Although some psychological communication is allowed with the girls at the head of the column, who stare unselfconsciously at the spectator, the impact of the watercolour depends on its evocation of a raw and blustery day.

During the 1880s James McNeill Whistler turned increasingly to watercolour, and in doing so brought the medium into the forefront of aesthetic advance. He exhibited a group of watercolours for the first time in 1884 as *Notes – Harmonies – Nocturnes* at the Dowdeswell Gallery. As a watercolourist Whistler was indebted to the optical lessons of French Impressionism and to the minimalism of form of Japanese art. In addition he was the spiritual descendant of Turner, whose abstract and beautiful later drawings and colour studies were otherwise little appreciated or understood. Whistler believed that an artist should select and arrange the appearances of nature to achieve his own aesthetic purpose. He stated in his 'Ten o'clock' lecture of 1885: 'Nature contains the elements, in colour and form, of all pictures, as the keyboard contains the notes of all music. But the artist is born

to pick, and choose, and group with science, these elements, that the result may be beautiful.'

Whistler was one of the artists who rediscovered watercolour's potential for spontaneous and calligraphic effects. In *Chelsea Shops* (Plate 83) buildings and figures are suggested by merging and overlapping patches of colour; areas of the paper have been wetted so as to allow pigment to spread over and into the surface, and to ensure that colour and detail would be subordinate to atmospheric tone. What might appear superficially to be a haphazard technique in fact required great deftness and precision and exploited the intrinsic qualities of the medium and materials. Whistler's aim was to prompt the mind's eye to imagine the scene without reference to conventional and, to his mind, banal realism.

His attitude towards the type of watercolour painting which displayed meticulous finish and depended on hours of work is indicated by his remark: 'A picture is finished when all trace of the means used to bring about the end has disappeared. To say of a picture, as is often said in its praise, that it shows great and earnest labour, is to say that it is incomplete and unfit for view.'

Whistler was well known for his artistic audacity and pugnaciousness. He came to be seen as representative of the modern movement in British art, and had both acolytes and imitators. His stylistic innovations were, however, better appreciated in Scotland than in England. Arthur Melville's *Kirkwall* (Plate 84) expresses the dour character of a fishing port in the Orkney Islands; brown and purple colours are blended together in a surface which is granular and seemingly still wet.

Gradually a more relaxed and informal style of watercolour painting was adopted, and even by artists whose subject pictures were grandiose relics of history-painting. William Frederick Yeames was typical of late Victorian academicians who also occasionally painted beautiful watercolours. His *On the Boulevards – Dinan – Brittany* (Plate 87) captures the flavour of a French provincial town seen from an unexpected angle. The turrets, mansard roofs and towering chimney stacks, and the ivy-clad ramparts crenellated by pots of geraniums, seen beyond a framework of tree-trunks and fencing, make a rich pattern of shapes and colours.

Only during the 1880s did English artistic life come to recognize the presence of a progressive faction which sought to create a form of painting which was self-consciously modern. The New English Art Club, founded in 1886, provided a forum for oil painters and some watercolourists who believed that the institutions and approach of British art was parochial and outmoded. However, the diversity of styles and approaches is indicated by the *Art Journal*'s comments about the Water-Colour Society's Summer Exhibition of 1886: 'The display made by the Royal Water-Colour Society includes much work that is of the very finest quality, and also much that is out of date, if not entirely obsolete.'

In fact, most watercolourists were resistant to European ideas of what constituted modern art, and many continued to produce works which derived from an idiosyncratic and native tradition. Landscape remained the principal genre and was treated with a particular concern for the specific character of places. In landscape painting, as with figurative and imaginary subjects, a revival of Pre-Raphaelite principles of observation occurred; the most interesting landscape watercolourists who operated in the 1880s and 1890s sought to describe the colours and natural forms of hidden corners of the countryside rather than give a general impression of the scene. They were interested in the contrasting characters and subtle variations between the countryside of different localities, and the way in which the seasons and weather relentlessly determine the appearance of the environment.

Wilmot Pilsbury lived in Leicestershire and painted landscapes and farm subjects which are utterly convincing. His *Landscape in Leicestershire* (Plate 85) allows the spectator to breathe the air of the Midlands farming country; the haphazard distribution of trees and hedges and the patterns of the waterlogged foreground testify to the artist's fidelity of observation and direct experience of the countryside.

Pilsbury was relatively well known as a watercolourist who exhibited in London and as the head of the

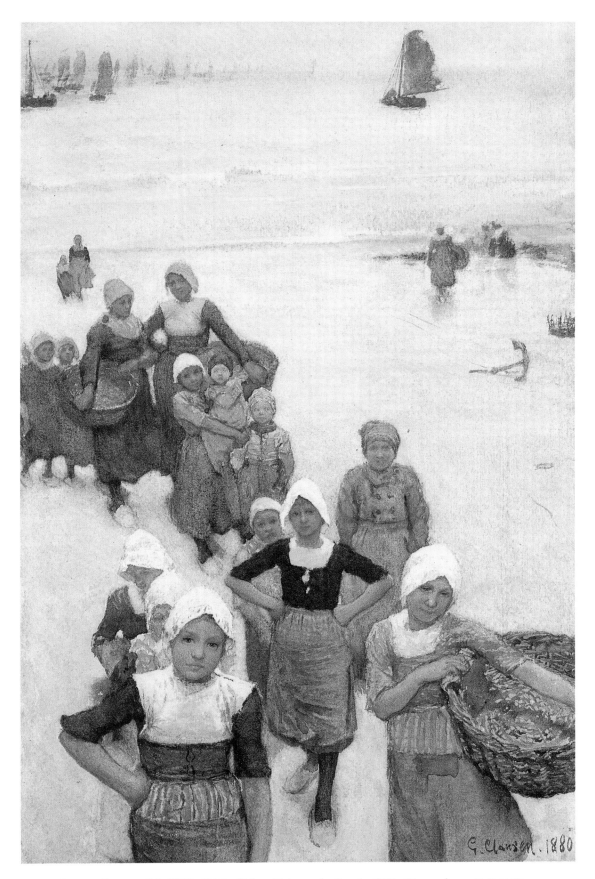

82. Sir George Clausen, RA (1852–1944). *Fisher Girls on the Beach*, 1880. Watercolour, 41.3 × 26 cm. (16¼ × 10¼ in.) Bedford, The Cecil Higgins Art Gallery

83. James McNeill Whistler (1834–1903). *Chelsea Shops*. Watercolour, 12.5 × 21 cm. (4⅞ × 8¼ in.) Washington, D.C., Freer Gallery of Art, Smithsonian Institution

84. Arthur Melville, ARSA, RSW, RWS (1855–1904). *Kirkwall*, 1880. Watercolour, 36 × 55 cm. (14 × 21¾ in.)
Glasgow Art Gallery & Museum

85. Wilmot Pilsbury, RWS (1840–1908). *Landscape in Leicestershire*, 1880. Watercolour and bodycolour, 25.1 × 35.3 cm. (9⅞ × 13⅞ in.) Collection of Mr and Mrs Michael Bryan

86. William Fraser Garden (1856–1921). *A Mill near St Ives*, 1889. Watercolour, 28 × 39 cm. (11 × 15⅜ in.) Private collection

Leicester School of Art. By contrast William Fraser Garden was an obscure, and perhaps reclusive, individual who lived in Bedfordshire in the south Midlands. He was none the less a watercolourist of remarkable talent, whose works reveal the face of the countryside with extraordinary objectivity. *A Mill near St Ives* (Plate 86) shows an ancient water-mill, constructed from brick and wooden clap-boarding and tiles. Miscellaneous sheds are clustered about the miller's house and are softly reflected in the water of the mill-pool. At the extreme right of the composition the spire of a parish church rises beyond thatched roofs. The details of architecture and of the trees and foreground meadow are recorded with pellucid clarity, the result of the artist's minute scrutiny of the scene.

George Marks was a watercolourist associated with the counties of Kent, Surrey and Sussex. Like Pilsbury and W.F. Garden he developed a most fastidious technique with which to record the unspectacular scenery of southern England; he tended, like them, to prefer compositions in which the eye is contained within an enclosed foreground. In *At the Edge of Shere Heath* (Plate 88) he has studied a rabbit warren amongst gorse bushes, the brilliant yellow flowers of which strike a jarring note in the otherwise bland scheme of colours.

The pure landscapes of John William North are amongst the most remarkable of all late Victorian watercolours. Herbert Alexander gave an account of how North adapted his technique in his later work: 'North, inarticulate, slow, with a mind for minuteness as if he were creating the universe, was gradually perfecting a water-colour technique which eliminated the use of body colour, at the same time giving pure colour greater depth and range of tone.'

The Old Pear Tree (Plate 90) is a most harmonious essay in the colours of autumn: golden fruit weighs down the ravaged trunk and branches of the tree, and the yellows and browns in the foreground and tangled distance suggest the last still days of the year. The effulgent colours of summer have drained from the landscape, and fecundity has given way to decay.

North is quoted as having said that 'Pictorial art is a translation of a poem in the language of nature which cannot be written in words.' His artistic objective was to give abstract expression to the beauties, both wistful and joyous, of the countryside. Alexander wrote of his friend:

> North's interpretation of nature was like that of the poet. He did not sit down, like the average landscape painter, in picturesque scenery and arrange it improvingly; but living his life full of varied interests he waited until an entrancing moment in the passage of light or some human episode happily related to its surroundings awoke in his heart the ecstasy which is the poetic state. Then no sacrifice of time or labour was too great in the searching of nature to aid his revelation. (*Old Water-Colour Society's Club*, Fifth Annual Volume, 1927–8)

North's original intention in *The Old Pear Tree* was to illustrate Spencer's *Shepherd's Calender* and the watercolour was first exhibited with the title *Cupid in the Pear Tree*. He subsequently eliminated the two or three *amorini* that he had painted entangled in the tree's branches, and thus made the watercolour a more private and intimate exploration of an uninhabited landscape.

North had remained in the countryside of Somerset, the beauties of which he had explored with his Idyllist friends Walker and Pinwell. He was an unpretentious and perhaps eccentric figure in middle age, little known in the wider context of artistic life but much admired by a circle of friends. Herkomer, who owned *The Old Pear Tree*, was instrumental in making North's name more famous; and his watercolours of a mythic and yet accessible landscape became influential for younger watercolourists in the 1890s and after the turn of the century.

Hubert Coutts shared North's interest in the precise evocation of a particular season. His reputation, however, was restricted to the North of England where he lived and painted. In his large watercolour *A Sheep Farm in the Duddon* (Plate 89) he has studied the landscape of the Lake District in early spring. A farmstead is seen

87. William Frederick Yeames, RA (1835–1918). *On the Boulevards – Dinan – Brittany*. Watercolour, 24.7 × 34.9 cm. (9¾ × 13¾ in.) Private collection

88. George Marks (fl. 1876–1922). *At the Edge of Shere Heath*, 1890. Watercolour, 55.3 × 36.8 cm. (21¾ × 14½ in.) Private collection

89. Herbert Coutts, RI (d. 1921). *A Sheep Farm in the Duddon.* Watercolour, 50.8 × 80 cm. (20 × 31½ in.) Collection of Mrs Harriet Dorment

90. John William North, ARA, RWS (1842–1924). *The Old Pear Tree*, 1892. Watercolour, 72.4 × 96.4 cm. (28½ × 38 in.)
Southampton Art Gallery

below a hillside lit by wintry sunshine and crested with snow; craggy outcrops and stone-built walls appear as grey masses against a golden background of dead and recently snow-crushed bracken. In the valley bottom sheep graze on the sparse vegetation while a farmer plants turnips or mangels. The authenticity of a such a view depended on the artist's own familiarity with the northern landscape, and his experience of its extremes of climate.

A number of watercolourists specialized in the painting of gardens, a late manifestation of the Victorian love of cataloguing and recording the appearance of the outside world. Watercolour had long been used to show the appearance of houses in the landscape, but only in the last two decades of the century did the increasing fondness of landscape painters for specific and secluded subjects and the delicacy and lightness of pure watercolour technique combine in the painting of garden subjects.

The interest in the theory and history of gardening also led to a spate of books, which were often illustrated with watercolours by contemporary artists. *Roses and Pinks, Levens Hall, Westmorland* (Plate 91) by George Samuel Elgood appeared as a plate in Gertrude Jekyll and Elgood's book *Some English Gardens*. The watercolour has a bright freshness of technique which allows a feeling of open daylight to illuminate the whole, and a subtle translucence of colour in the bright reds and pinks of the foreground roses and the dense bluish-greys of the topiary. The overall composition is held together by the carefully observed shapes and conjunctions of the sculpted yew hedges, and by the sense of recession into an atmospheric distance.

Ernest Arthur Rowe was perhaps Elgood's principal rival as a watercolourist of garden subjects; the two were fellow-exhibitors at the Royal Institute. His view of *The Gardens at Campsea Ashe* (Plate 92) is more rigidly organized in its perspective than Elgood's view of the gardens at Levens Hall, but is delightful for the shapes and contrasting colours of yew hedges and dainty flower-beds.

Men and women found consolation and spiritual refreshment in gardens and Victorian landscape art served the desire that many felt to escape from the aggressive and competitive world of the cities. Through art they could meditate on the beauties of wild or cultivated nature.

Lionel Percy Smythe's watercolour *Springtime* (Plate 93) was perhaps a tribute to Fred Walker, whose own *Spring* (see Plate 56) had been painted twenty-one years earlier but remained familiar from Robert Walker Macbeth's reproductive etching. Smythe observed his model at even closer range than Walker did, and engages the spectator's sympathy for her as she struggles through the undergrowth of pussy willow.

A luxuriant image of summertime indolence forms the subject of Edward John Gregory's *Marooning* (Plate 94). Two girls are seen in an enclosed and densely patterned river landscape; one of them stands on the gravel banks of the river, while her companion, who reclines blissfully in a canoe, drifts on the river's sluggish current. The fluency of Gregory's watercolour technique brilliantly conveys the golden light and purple shadows of a late afternoon in high summer; his use of bodycolour in certain isolated areas causes the foliage and rippling water to sparkle in the sunshine.

If Gregory offered a vision of an undisturbed setting and gorgeous weather, others revealed a world of privations and sadness. John Henry Henshall's *Behind the Bar* (Plate 95) is an elaborate reconstruction of a London public house, seen from the proprietor's side of the counter. The figures who stand in the public bar represent a variety of types: a bearded musician or busker, a woman who spoon-feeds her child-in-arms, and an old fellow who is besought by a younger man to leave the pub. On the left side of the composition is a view into the private bar or snug where more affluent customers have congregated: a couple whisper to one another and a man talks to the barmaid. Henshall has given a dispassionate view of working-class life, but the essential moral of his subject is made clear by the sign 'Roberts Pawnbrokers' seen on the far side of the street, a business which flourished because of the hardships and exigencies of the lives of the assembled company.

Henshall's *Behind the Bar* was exhibited at the Dudley Gallery in 1883. It represented a relatively modern

91. George Samuel Elgood, RI (1851–1943). *Roses and Pinks, Levens Hall, Westmorland*, 1892. Watercolour, 31.8 × 49.5 cm. (12½ × 19½ in.) Private collection

92. Ernest Arthur Rowe (d. 1922). *The Gardens at Campsea Ashe*. Watercolour, 30.5 × 45.7 cm. (12 × 18 in.) Private collection

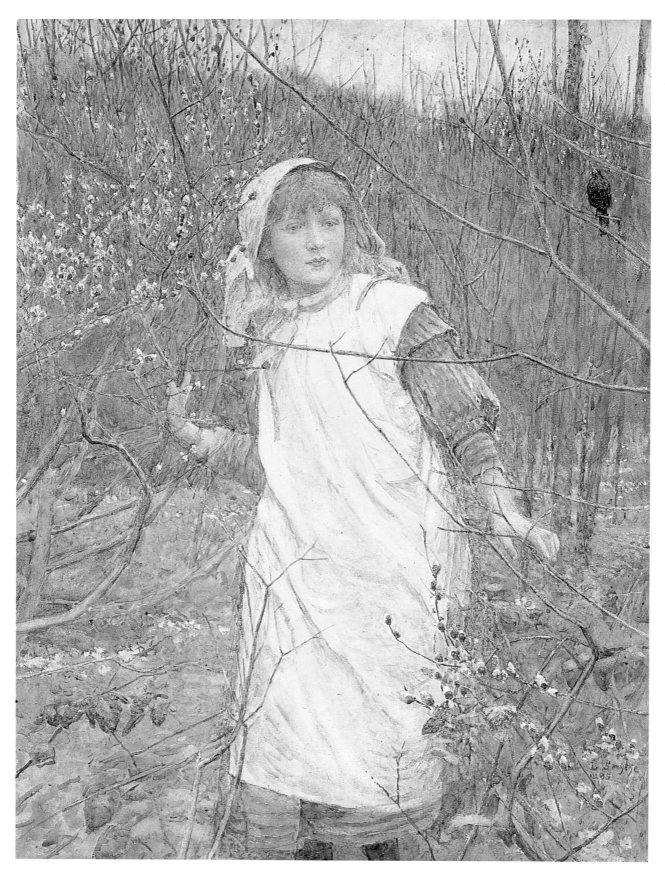

93. Lionel Percy Smythe, RA, RWS (1839–1918). *Springtime*, 1885. Watercolour, 52.7 × 38.7 cm. (20¾ × 15¼ in.) Private collection

94. Edward John Gregory, RA, RI (1850–1909). *Marooning*, 1887. Watercolour and bodycolour, with scratching out, 36.8 × 45.7 cm. (14½ × 18 in.) London, Tate Gallery

95. John Henry Henshall, RWS (1856–1928). *Behind the Bar*, 1882. Watercolour and bodycolour, 40 × 71.8 cm. (15¾ × 28¼ in.) Museum of London

96. Walter Langley, RI (1852–1922). *'But Men must work and Women must weep'*, exhibited 1882. Watercolour, 90.5 × 53 cm. (35⅝ × 20⅞ in.) Birmingham Museums and Art Gallery

97. Carlton Alfred Smith, RI, RWS (fl. 1871–1916). *Recalling the Past*, 1888. Watercolour, 76.2 × 52.1 cm. (30 × 20½ in.) London, Victoria and Albert Museum

style of watercolour painting, which was concerned with the cast of light over the forms and textures of the interior. Although the paint is not minutely handled a remarkable sense of physical realism is conveyed.

Two watercolours of scenes of distress from the 1880s, by Walter Langley and Carlton Alfred Smith, reveal different approaches to the realistic description of interiors. In Langley's 'But Men must work and Women must weep' (Plate 96) a sombre mood is evoked by drab colours and rough textures. Carlton Smith's Recalling the Past (Plate 97) is a product of the Victorian fascination with artistic reconstruction and minute detail; each piece of furniture and each fold of the girl's dress is meticulously described. In both pictures the contents of the interior depend for their brightness and three-dimensionality on raking light from a single source.

Langley's subject, in which the tragic death of a fisherman is foreshadowed in the anxious faces of the two women, was inspired both by a real event and by a poetical description of a similar tragedy. One night while reading Charles Kingsley's The Fishers Langley was alarmed by the signal that warned the fishermen of impending storm; he later described how 'He went out into the black night – an awful storm was howling – and he saw the blue rockets being fired from Penzance as a signal to those who were at sea. The scene was in the last degree impressive – a fearful constraint to his cosy fireside – and the idea at once suggested itself.' Carlton Smith's theme seems to be one of bitter recrimination or despair, felt by a woman who recoils in private misery from a series of letters that she had sought to destroy.

In the later years of the nineteenth century the lessons of French Impressionism were variously adapted or ignored by British artists. The virtue of watercolour as a medium in which technical experiments and pictorial arrangements might be tried out was as important as ever. The French painter Bastien-Lepage insisted that a painter should always carry a sketchbook, and had told John Lavery to 'Select a person – watch him – then put down as much as you remember. Never look twice.' A Rally (Plate 98) may have been painted in response to this advice; the scale and action of the principal figure, and the use of dramatic foreshortening which places the foreground figure in conjunction with the opponent, speak of the artist's immediate observation of the scene. The large oil painting A Tennis Party (Aberdeen Art Gallery) for which this watercolour was a related study seems static by comparison, and does not express the physical effort of reaching and returning the ball which is seen in A Rally. Equally, while the oil painting is finished to a consistent level of detail across its panoramic surface, the watercolour concentrates the spectator's eye on the dynamic movement of the central figure by allowing the composition's peripheral areas to fade into a granular blur.

Amongst the most technically brilliant watercolours of the nineteenth century were those of Lavery's friend Joseph Crawhall. The Governess Cart (Plate 99), painted in the very last years of the century, consists of flickering touches of opaque colour, concentrated at certain points to give intense luminosity, and washes of transparent watercolour which unify and make harmonious the overall composition. It is an extraordinary combination of precise delineation and dextrous brilliance of colour, with a near abstraction of calligraphic handling on a strongly grained linen sheet.

Crawhall learnt from the painting of Whistler the vital importance of a quality of apparent effortlessness in a picture. The Governess Cart depended not on laborious execution but on an intellectual preparedness to receive and transmit spontaneously an impression of one's surroundings, linked to extreme deftness of touch. This remoteness from the physical world, and yet telling approach to it, which was the technical antithesis to the work of most earlier watercolourists, stemmed from a new and existential aesthetic approach in the closing years of the nineteenth century.

98. Sir John Lavery, RA (1856–1941). *A Rally*, 1885. Watercolour, 65.9 × 63.4 cm. (26 × 25 in.) Glasgow Art Gallery & Museum

CONCLUSION

Whatever the qualities and achievements of British art during the reign of Queen Victoria may have been, it is undoubtedly the case that no age before or since has been so prolific or so various in its creativity. In the area of watercolour painting this vast diversity stems from the range of purposes to which the art was put. Watercolour was seen as a medium to be used for the expression of the imagination in pictorial form; but also as a means of recording the appearance of the physical world. At every stage between these opposite poles of artistic objective painters gave more or less subjective interpretations to the images that they observed or invented; and many technical adaptations were made to assist the artist's purpose of getting and transmitting visual information or revealing a private vision of the world.

Victorian watercolour painting reflects a lost view of the world, and allows us to investigate the minds of the artists of that age. The insights and prejudices, the open-mindedness and dogmatic conviction, the richness of taste and imperfect discrimination, that are displayed in an art that was on occasions ingenuous and sincere and on others self-conscious and defensive, are a source of information about a vanished civilization. Watercolour painting is the most direct and consistent expression of the Victorian artistic sensibility.

99. Joseph Crawhall (1861–1913). *The Governess Cart*. Watercolour and bodycolour on linen, 30.5 × 37.5 cm. (12 × 14¾ in.)
Glasgow, The Burrell Collection

SELECT BIBLIOGRAPHY

Adetailed account of artistic life and preoccupations during the second half of the nineteenth century is given in the pages of the *Art Journal* and the *Magazine of Art*; I have quoted extensively from the former in the belief that this contemporary source conveys a feeling both of the minutiae and of the generality of Victorian art. The *Art Journal* and the *Magazine of Art* were published in monthly instalments from 1849 to 1911 and from 1878 to 1903 respectively, and may be consulted at the National Art Library at the Victoria and Albert Museum in London. Catalogues of the exhibitions held by the various societies of watercolourists may also be seen there.

John Ruskin's *The Elements of Drawing* was a response to the many requests for instruction and advice that he received during the time that he taught in the landscape school of the Working Men's College. It was first published in 1857 and, with *The Elements of Perspective* and *The Laws of Fésole*, which are also treatises directed at painters, constitutes Volume XV of Cook and Wedderburn's Library Edition of Ruskin's works, published in 1903–12. Ruskin's other works from which I have quoted, *Modern Painters* and *Notes on Samuel Prout and William Hunt*, were published in 1843–60 and 1879–80 and constitute Volumes III–VII and part of Volume XIV respectively, of the Library Edition.

Numerous autobiographies and monographs have been written by and about Victorian artists; however, these are too many to list here. Students of Victorian art will find an invaluable bibliography at the conclusion of the third volume of Martin Hardie's *Water-Colour Painting in Britain*; other useful bibliographies are to be found in Christopher Wood's *Dictionary of Victorian Painters* (revised edition 1979); the subject index of the National Art Library provides a record of more recent publications. Brief biographical accounts of many Victorian watercolourists are to be found in Huon Mallalieu's *Dictionary of British Watercolour Artists* (two volumes; revised edition 1986) and Christopher Wood's aforementioned *Dictionary of Victorian Painters*. The Annual Volumes of the Old Water-Colour Society's Club, which have been published since 1924, provide biographical essays and lists of exhibited works for many nineteenth- and early twentieth-century watercolourists. Those who want to see a wider range of reproductions of watercolours by Victorian artists are recommended to visit the Witt Library at the Courtauld Institute of Art, University of London.

The watercolour societies have been described by J.L. Roget, whose *History of the Old Water-Colour Society, now the Royal Society of Painters in Water Colours*, appeared in 1891, and by Charles Holme, whose *The Royal Institute of Painters in Water Colours* was published in 1906. I have consulted and quoted from both of these texts.

The last twenty years have seen a spate of publications and exhibition catalogues of great interest to anyone who admires Victorian art. Amongst these is Allen Staley's *The Pre-Raphaelite Landscape* (1973), the themes of which have a constant bearing on watercolour painting. Exhibitions which have consisted of or included watercolours have been organized by the Yale Center for British Art in New Haven, Connecticut, *The Exhibition*

Watercolor (1981); the Tate Gallery in London, *The Pre-Raphaelites* (1984); and the British Museum, *British Landscape Watercolours* (1985).

The first and foremost general history of Victorian watercolour painting remains the third volume of Martin Hardie's *Water-Colour Painting in Britain, The Victorian Period*, which was published after Hardie's death, in 1968. Conscious of the magisterial importance of this monument of scholarship, I have been encouraged by its comprehensiveness and even-handedness towards a more subjective and indulgent selection of plates and approach to the text in my own book.

PHOTOGRAPHIC CREDITS

INDEX